Watercolour
plus ...

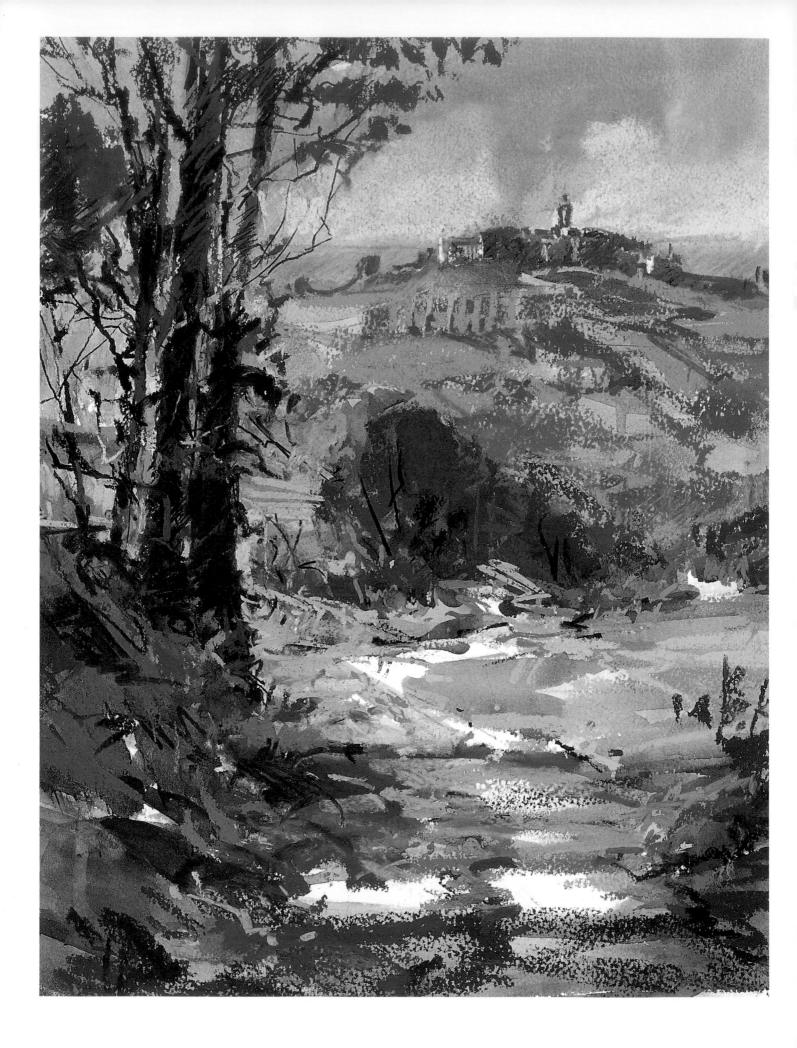

Watercolour *plus* ...

enhance your watercolours with other media

Edited by Ray Balkwill

David & Charles

A DAVID & CHARLES BOOK

First published in the UK in 2002

A catalogue record for this book is available from the British Library.

ISBN 0 7153 1253 7 (hardback)
ISBN 0 7153 1456 4 (paperback)

Printed in Singapore by KHL Printing Co Pte Ltd
for David & Charles
Brunel House Newton Abbot Devon

Commissioning Editor Sarah Hoggett
Senior Editor Freya Dangerfield
Copy Editor Ian Kearey
Designer Casebourne Rose
Step Photography Nigel Cheffers-Heard,
Alwin Greyson (pages 52–63)
Production Controller Kelly Smith

page 2 ***Roddino from Cissone, Piemonte*** Ray Balkwill

Watercolour *plus* ...
CONTENTS

Watercolour *plus...* INTRODUCTION

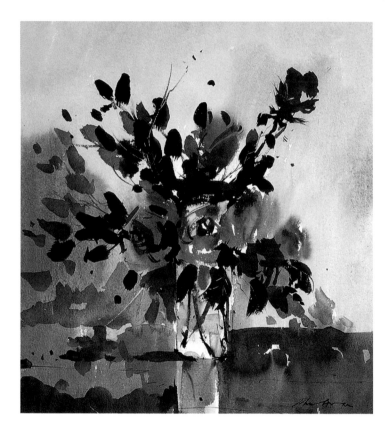

Flowers in Vase
35.5 x 53.5cm (14 x 21in)
John Hoar
Much of this painting was constructed around the negative shapes between the leaves, stalks and petals. The watercolour and ink were then applied working from light to dark.

WATERCOLOUR PLUS... is not just another 'how to paint in watercolour' book – it is a thoroughly practical introduction to painting in mixed media. Its combination of instruction and inspiration will be invaluable to all watercolourists who wish to take their work a step further, providing an insight into how a number of respected artists combine watercolour with other mediums, without abandoning the very qualities that attracted them to watercolour in the first place. Today, watercolour is still the most popular medium used, but it also the most difficult to master: its characteristics of translucency, expressiveness and unpredictability demand much forward planning by the artist. There is no other medium quite like it, however, and despite any frustrations and disappointments it might bring, it is uplifting when it works.

For many years I worked solely in watercolour, striving to master its elusiveness, and at one point I realised that my paintings were becoming too 'safe'. It was then that I decided to devote some time to experimenting with combining watercolour with other media.

An envious friend once told me how lucky I was to be an artist. 'After all,' he said, 'painting is easy – it's just a matter of mixing the right colour and putting it in the right place.' If only it were that simple! Painting demands more than just a basic knowledge and sound technique; one must have inspiration, a desire to paint and fresh challenges to paint well. That's not always as easy as it sounds, though – the starting point for any artist is being faced with a sheet of white paper, and that can be a daunting prospect, not only for the beginner, but also for the professional artist. Finishing a painting, and

knowing when to stop before it is overworked,
are problems of equal importance.

This book shows how each artist sets about their
task, from sketchbooks and reference photographs
right through to the finished picture. The detailed
step-by-step sequences give an insight into the
thinking and working processes of how a professional
artist goes about creating a painting. And within the
'gallery' pages, examples of further work by each
artist provide another invaluable source of
inspiration.

No book on watercolour would be complete
without some mention of the great masters: J.M.W.
Turner, John Constable and John Singer Sargent are
great favourites for very different reasons – and all
mixed their media. Turner was a genius in the

Late Summer
30.5 x 40.5cm (12 x 16in)
Martin Decent
*An unused country lane is the source of this painting., where
a series of watercolour washes overlaid with gouache shows the
artist's overriding interest in the harmony of colour.*

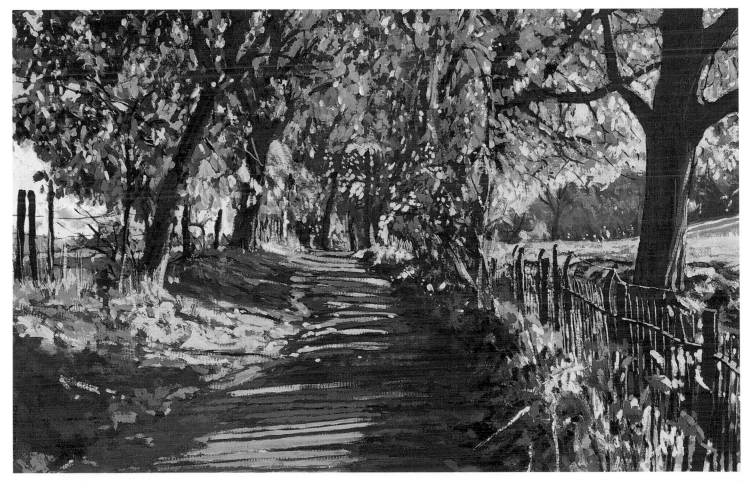

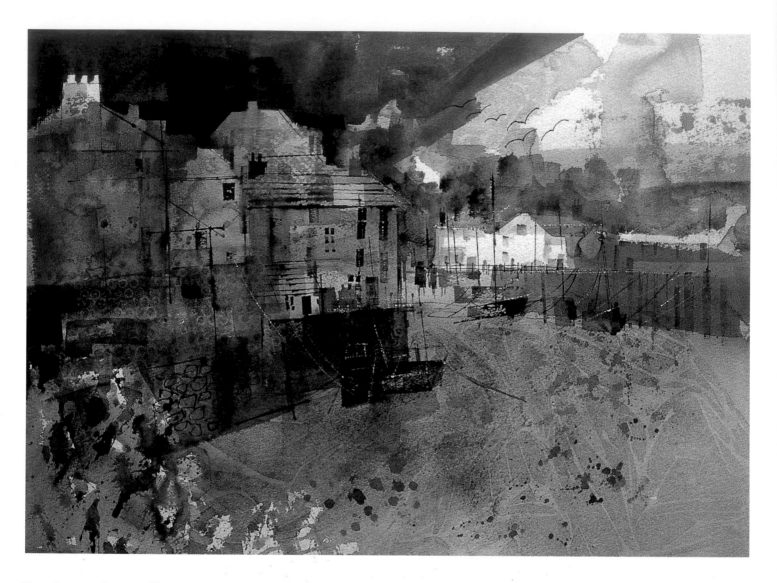

Port Isaac, Cornwall
53 x 71cm (21 x 28in)
Mike Bernard
This painting was developed from a pencil sketch made while on holiday in Cornwall. The artist decided to use one of his favourite limited palettes, quinacridone gold, brown madder and indigo.

translation of his feelings and vision in paint, and a particular master in making the medium his servant. A look at his sketches shows that he used body colour, chalk and pen and pencil with watercolour, where and when it suited him.

Constable was painting at around the same time, but saw his subjects in a different way, striving to capture realism in his paintings. In particular, his sensitively observed sketchbook sky studies in watercolour and body colour are awe-inspiring.

Sargent's watercolour technique was brilliant, employing a wide range of methods and materials to achieve his effects. He, too, would use body colour

in his watercolours, setting the translucent against the opaque, and his paintings look as fresh today as when they were painted, over a hundred years ago.

Many contemporary painters – among them Moira Huntly, John Blockley, Aubrey Phillips, Leslie Worth and Rowland Hilder – have contributed to an adventurous approach to painting, using innovative ways of combining watercolour with other media in their work.

You may already be familiar with some of the artists featured in this book: they are all different from each other, and I hope you will find the diversity of subject matter, approach and materials used exciting. Each is individual in his or her way of thinking about a subject, some seeking a more representational outcome, others a more semi-abstract approach.

There are, of course, as many approaches and techniques as there are artists, but those featured here provide a wide and stimulating range of possibilities for you to consider. From Provence and the Peak District and Cornwall to Italy, they take you on their own personal journey of discovery. Painting thrives where there is a sense of adventure – and where better to set out on that adventure than right here and now?

Watercolour Plus... will, I hope, provide you with inspiration and be an invaluable source of ideas that you can incorporate into your own work – at whatever level of experience you may have reached. Remember, though, the most important thing is what you have to say: painting is all about making your picture and expressing your own vision.

Ray Balkwill

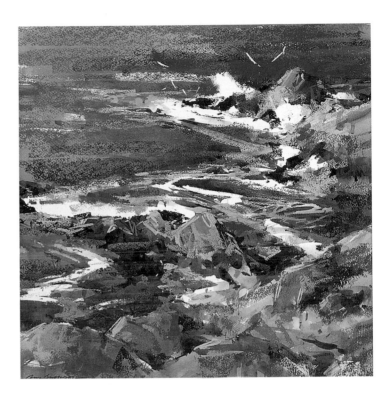

Rocks at Cape Cornwall
48 x 48cm (19 x 19in)
Ray Balkwill
The dignity and power of the sea should be expressed in a bold and direct way. Here, the use of watercolour and pastel combined helps to create the necessary movement and energy in the painting.

Watercolour
plus ...
Soft Pastel

When I use pastel alongside watercolour in a painting, I like to think of them coming together as one, a combination of drawing and painting in the same picture. Some artists merely use the watercolour as a tonal foundation, or underpainting on which to build up the pastel. I have seen others rescue a failed watercolour by adding pastel to it. Both approaches are valid, but my own views on painting with water-colour plus pastel are simply this: start out with the clear intention of combining the two mediums from the outset.

When the two mediums are combined, exciting things begin to happen. For a painting to succeed, you must treat them as opposites and seek to use the two mediums in a clearly contrasting way: think about hard marks against soft, light against dark, and warm colours against cool. This is the key to producing paintings that are rich in a variety of marks and textures. Don't feel restricted to 'conventional' techniques: there are no hard-and-fast rules, and the potential for your own individual interpretation is endless.

RAY BALKWILL

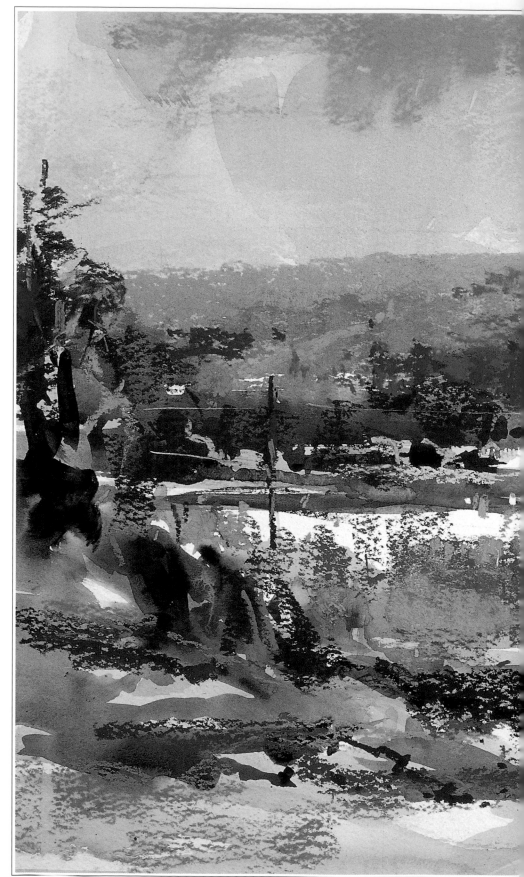

Roddino, Piemonte
35.5 x 53.5cm (14 x 21in)
This painting was done in situ *on a recent trip to Italy. The intense light, strong contrast of bright colours, and the variety of textures found in the landscape made watercolour plus pastel the obvious choice of medium.*

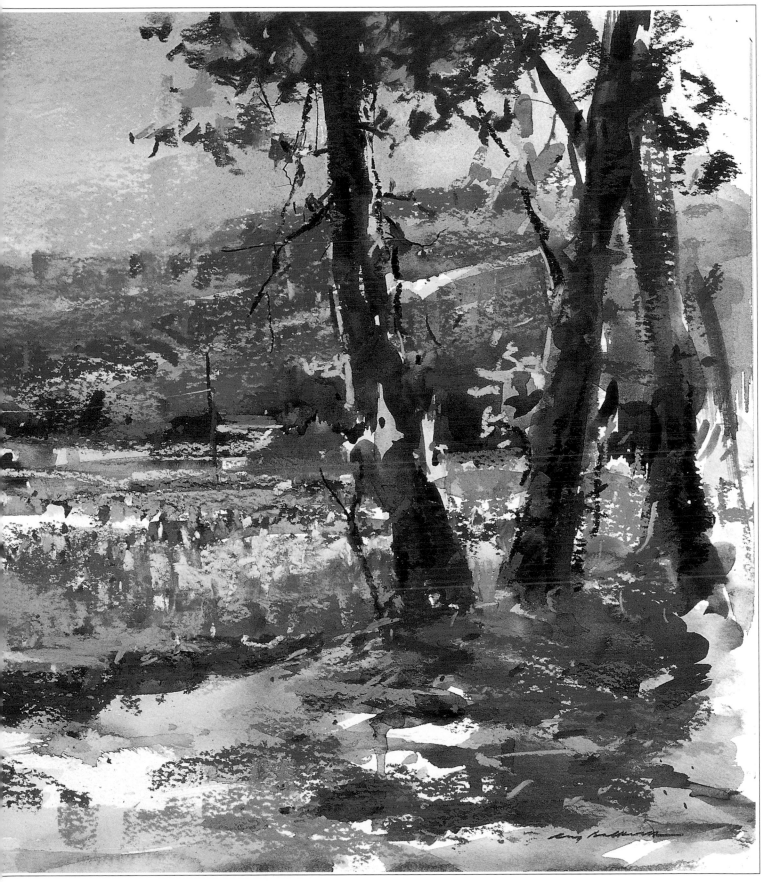

Materials

Techniques

Watercolours

I use mainly artists' quality paints in tubes, in preference to pans. However, I do occasionally use some of the students' range, particularly in the earth colours, as well as making up some colours myself.

I use masking fluid to reserve white paper for the highlights, and apply this with an old brush. Remember that masking fluid dries quickly, so be sure to wash your brush in soapy water before the masking fluid clogs the bristles.

Papers

A Not watercolour paper has an ideal surface for using pastel, but this varies from each manufacturer in whiteness, tooth and sizing. I have found that the Rough papers generally have too much tooth for the pastel and leave a rather 'mesh-like' look to the painting. It is worth experimenting with papers – my own particular favourites are Bockingford and Saunders Waterford. I use the 300gsm (140lb) weight, which I stretch onto a board with gummed tape.

Soft pastels

Pastels come in a wide range, and each manufacturer produces a vast number of colours from which to choose. My own pastel box for working *in situ* is a briefcase which I have partitioned, giving me 20 compartments for my grouping of colours. In the studio I also use a number of small boxes, again with groupings of blues, greens, and so on. It is made up of all the well-known

brand names, but a particular favourite of mine is Unison. The first thing I do is to remove the labels in order to use the side of the pastel more easily. Be sure to keep a reference chart of your colours, as it makes reordering much easier. You will find small boxed sets useful to begin with.

This section looks at some of the painting and drawing terms and the ways in which watercolour and pastel can be used together.

Pastels are a dry, opaque medium, but by blending or rubbing colours with your fingers, or lifting off with a tissue or kneaded putty eraser, as shown opposite, you can create a semi-transparent effect. Adding water to the pastel, using the wet brushing technique, will also render the pastel semi-transparent.

Although you might think that watercolour and pastel are very different mediums, there are in fact some classic watercolour techniques for which it is easy to find a pastel equivalent – as the following examples amply demonstrate.

Graduated tones

It is possible to achieve a similar effect to a graduated wash by using the pastel stick on its side and then blending it with a finger or torchon (a tightly rolled paper stump).

Letting the support show through

Lightly drag the side of a pastel across a textured support. The pastel dust will adhere to the raised areas of the paper and miss the hollows, allowing the white of the paper to show through.

Blending with water

This gives a similar effect to wet-in-wet watercolour, but in a more opaque way. Here, the pastels have been applied dry to the paper and then brushed over with water. The water acts as a fixative, so the colour underneath is not disturbed if you want to build up with further layers of pastel. Note how the pastel is taken off the top of the paper's grain, so that the character of the pastel strokes is retained.

OTHER PASTEL TECHNIQUES

Many pastel techniques are similar to those used with other drawing media. The difference with pastel is its powdery, chalky nature, which allows underlying colours and support textures to show through.

Blending pastel colours

Pastel colours can be blended together on the support so as to make many additional colours. Gently rub your finger or the side of your hand over the areas you want to blend. This is very effective for skies and reflections.

Lifting off pastel

Here, a zigzag shape of masking fluid was applied to the paper before a watercolour wash was put down. Once the wash was dry, the masking fluid was rubbed off, leaving an area of white paper. The pastel was then dragged across the paper surface on its side. Using tissue paper, I rubbed out the left-hand side to leave only a hint of colour. If you want to take the paper back to white, lift off the pastel further with a kneaded putty eraser.

Side strokes

This stroke was made using the side of the pastel; it is often used for covering large areas, such as skies. You must learn to control the pressure so that you can achieve the exact tonal value you require. This mark will give the effect of broken colour and allow other colours beneath it to show through – very effective when you use contrasting or complementary colours.

Line strokes and hatching

You can create a very different mood by working with the tip of the pastel. The marks will vary depending on the size, shape and softness of the pastel: Conté crayons are much harder than conventional pastels and are useful for finer detail. Hatching (above left) is useful for texture and shadow.

Scumbling

Here, a number of colours are lightly applied over one another so that each colour only partially covers the one below. Exciting effects can be created by using complementary colours; if lighter tones are used, for example for skies, you will achieve more subtle results.

PROJECT:
Rocky Shore

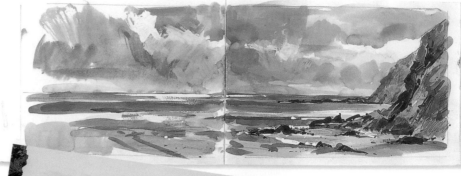

The sea has long held a fascination for artists, and the elemental forces in nature and the wide open spaces of sea and sky have been a major influence in my work.

For this studio demonstration I used a total of just 17 pastels out the hundreds I could have chosen from. It is far better to use a limited range of values and exploit them to the full – after all, your goal should be one of unity, a perfect harmony of values and colour.

I work with the board held almost vertical. This seems to make me work faster, as I battle with the watercolour washes while they run down the paper. It also gives me a better chance of viewing the painting from a distance. At the pastel stage, too, it is important, as any excess pastel will drop down without dirtying the painting.

I wanted to direct the viewer's eye through the painting to the wave crashing on the distant headland. Because of the sheer scale of the subject, seascapes do not always have an obvious focal point, and therefore it is

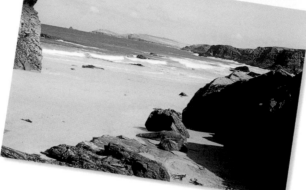

up to the artist to create one. The size and tonal value of the rocks cropped on either side also play an important part in creating the overall composition.

Left and above: I used this photo as little as possible and tried to rely on my memory and watercolour sketches for colour. The disadvantage of working solely from a photograph is that it often gives far too much information, and this can result in a too detailed and representational painting.

Artist's Tips

■ I never use fixative with my pastels, as it darkens the lighter colours. However, it does not affect the darks, so if you wish to build up the painting on a darker foundation of pastel, spray this first.

■ Mistakes in pastel can be easily erased using a razor blade, hog hair brush or kneaded putty eraser.

■ For cleaning pastels I shake dirty sticks in a small container of ground rice. This soon gets off any loose dust from other sticks.

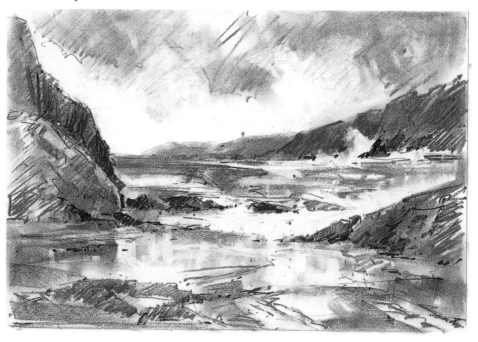

Above: This charcoal sketch was done on location and sorted out all my priorities — composition, tone, balance and centre of interest — so I used it as my main reference. I drew it on a smooth paper using a felt-tip marker pen, willow charcoal and Conté crayon, and lifted out the whites with a kneaded putty eraser.

Materials

- 38 x 56cm (15 x 22in) sheet of stretched 300gsm (140lb) Bockingford Not watercolour paper
- Masking tape
- 4B solid graphite pencil
- Black waterproof chisel felt-tip pen
- Masking fluid
- Watercolours:

 Winsor blue

 cerulean blue

 cadmium orange

 burnt umber

 burnt sienna

 raw sienna
- 2.5cm (1in) hake brush
- Mixing palette
- Unison soft pastels:

 brown earth 6 and 8

 additional 4, 31 and 35

 blue violet 10, 15 and16

 blue green 1 and 14

 dark 11

 grey 3

 yellow green earth 13
- Daler Rowney soft pastels:

 ultramarine 1 and 4, viridian 1

 purple brown 6
- Conté crayon:

 white

1 I drew the scene using a 4B solid graphite pencil and blocked in some dark areas using a black waterproof chisel felt-tip pen. Putting in some darks early on helps me with the composition. One good reason for using a pen, rather than charcoal or pastel, in the initial drawing is that the pen will not clog up the tooth of the paper. This allows me to apply more pastel at a later stage.

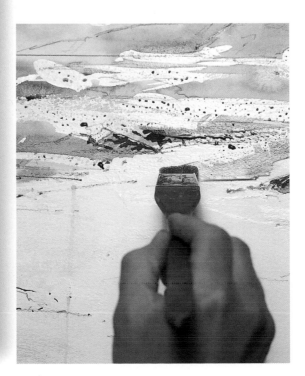

2 Using an old brush, I applied masking fluid to reserve the white of the paper for the waves and breakers. This was slightly diluted with water to make it easier to apply. When the masking fluid was dry I applied a broad wash of cadmium orange, merging it on the paper with Winsor blue for the sky. I then mixed the two colours together on the palette for the distant headland, keeping the mix on the cool side to accentuate the recession.

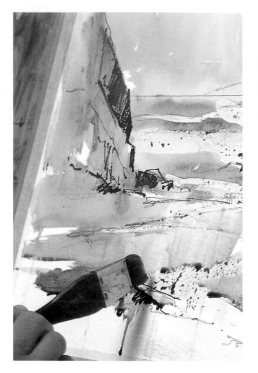

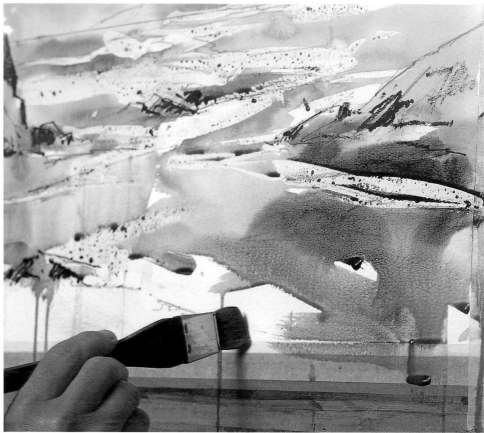

3 I continued down the painting with these colours to the foreground rocks. While they were still wet, I added raw sienna to the rocks on either side, and then dropped in burnt umber and raw sienna for the reflections on the sand.

4 While the foreground colours were still damp, I dropped in burnt sienna and burnt umber for the reflections of the rocks on either side.

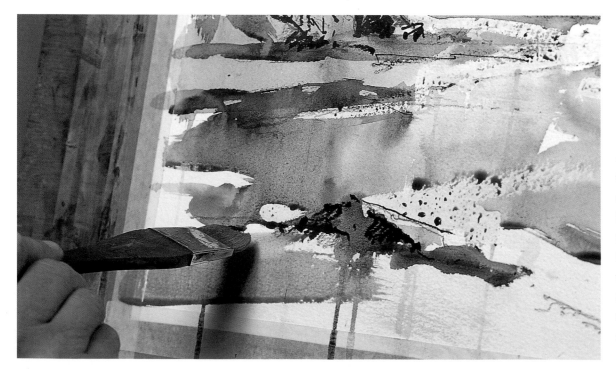

5 When the rock on the left was dry, I then added a mix of Winsor blue and burnt umber to give form and to build up the tonal value further. I also used burnt umber for the smaller rock in the foreground.

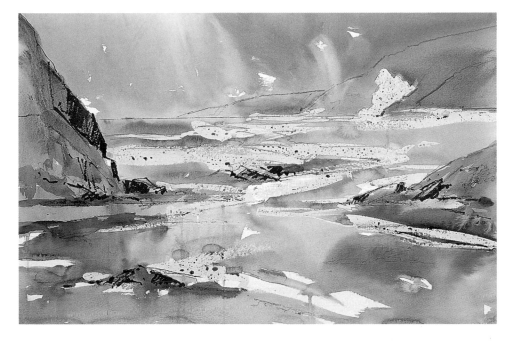

6 I then used a slightly stronger wash of the cadmium orange for the beach; the warm colours in the foreground helped the painting to recede. By this stage the basic watercolour was almost complete. All that remained to do now was to strengthen the colours to the right tonality.

7 I used a mix of Winsor blue and raw sienna for the distant headland, and then mixed a dark using Winsor blue and burnt umber for the rocks on either side of the main wave, and for the rocks in the foreground. A further wash of Winsor blue was added to the sea to accentuate the waves before removing the masking fluid in the next stage. I also dropped some burnt umber in the sea to the right in the middle distance, in order to strengthen the composition and prevent the eye from drifting out of the picture. I used cerulean blue to cover some of the white areas that had been left by accident in the foreground, and added further washes of burnt umber to the reflection on the left, as well as to the beach. Using the drybrush technique, I dragged on some burnt sienna to suggest seaweed and texture around the small rock.

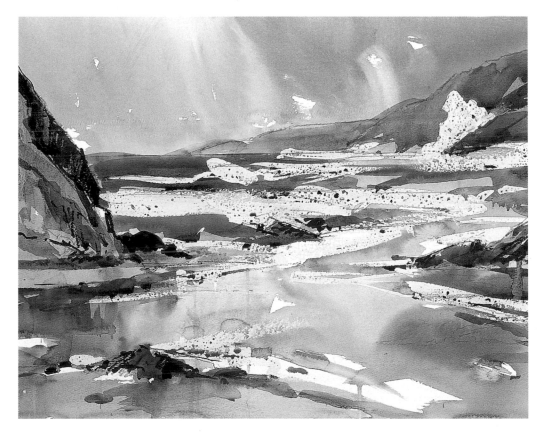

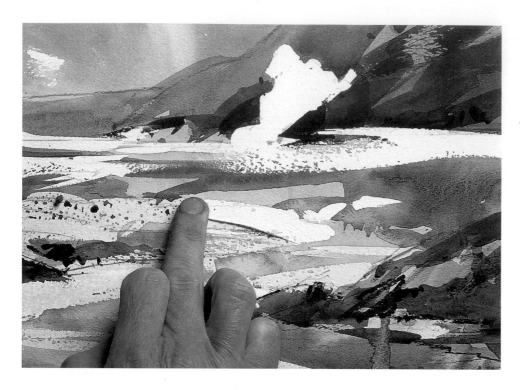

8 When the paint was completely dry I rubbed off the masking fluid with my finger. Because the medium is rather mechanical, it tends to leave hard edges. These can be softened with a brush and some water if necessary.

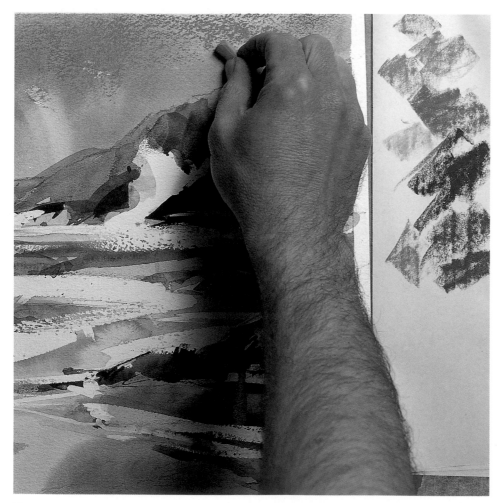

9 I always begin the pastel stage by starting at the top and working down. I wanted to retain some of the soft watercolour washes in the final painting, and therefore decided not to make the sky too busy. I put in a suggestion of cloud using a selection of purple greys, knowing that these would be echoed later in the sea and foreground. I used additional 31 on the left-hand side, blending it with my fingers, and I then scumbled blue violet 15 and additional 31 on the right. I usually tape a piece of paper to the board to try out colours before applying them. Remember, however, that colours will look quite different on a brilliant white background to how they appear when surrounded by other colours in a painting.

PROGRESS REPORT

The watercolour stage of the painting was now complete. I had achieved my aim of having a strong contrast and depth of colour in the watercolours, in order for the lighter colours of the pastels to work better over them. I kept the painting as simple as possible, in terms of both the colours and the brushstrokes used, as I would add the finer detail with pastels. The two complementary colours of blue and orange form the overall mood and key of the painting. I also incorporated a contrast of watercolour techniques, including drybrush and wet-in-wet, to suggest hard and soft passages where necessary. At this stage I do not worry about making any mistakes, as I can correct them if necessary when I am working with the pastels.

Rocks on either side hold the composition together and draw the eye through the picture to the sea beyond

Waves zigzag through the painting – an energetic compositional device

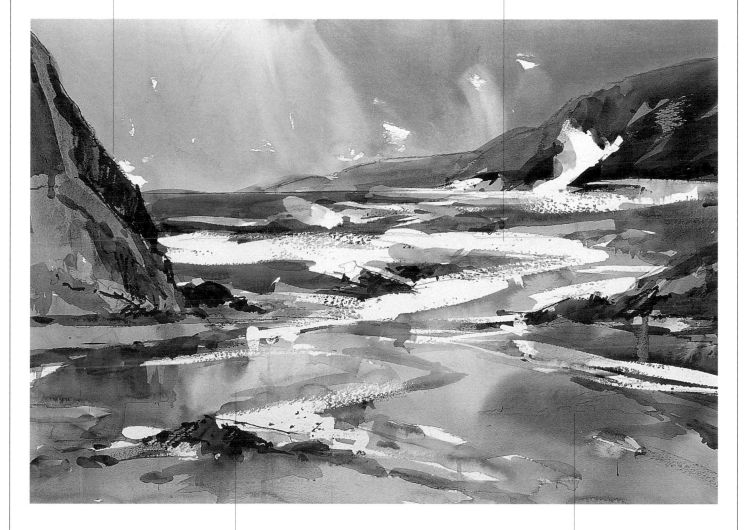

The reflections in the wet sand have a translucency that can only be achieved in watercolour

This reflection of the sky is critical in establishing a sense of the light that pervades the whole scene

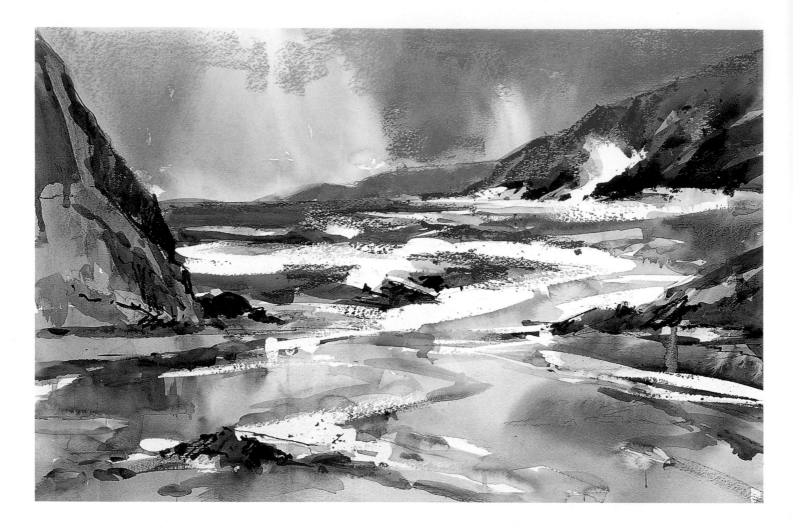

10 I now began to work down into the distant headland using lightly applied side strokes of green grey (grey 3) and purples (additionals 4 and 35 and blue violet 15), being sure to let some of the watercolour underpainting show through. Then I tackled the sea, using light and dark blue greens (blue greens 1 and 14, viridian 1, blue violet 10 and ultramarines 1 and 4).

11 I built up the rocks on either side by adding side strokes of brown earth 6 and then purple brown 6 and blue violet 16, using the tip of the pastel to give form to the rocks. The tooth of the paper is quite pronounced, and so texture can be suggested quite easily by using the paper surface to good effect. I then turned my attention to the beach area and used a brown earth 8 on its end to produce a linear mark across the reflections of the rocks, leaving some of the paper white to add 'sparkle' and contrast.

12 The wet-in-wet watercolour already suggests wet sand, so little was needed in the foreground area other than to repeat some of the lighter purple used in the sky. I did this using additional 31 on its side – the purple contrasts nicely with its complementary colour underneath.
Inset: Where I wanted a softer effect, I blended the purple pastel with my finger.

13 Moving water looks more realistic when it is understated, so I used light pressure with side strokes of broken colour, to make full use of the texture of the paper. To help soften the harshness of the masking fluid on the main wave in the distance, I added a light purple grey (additional 4) to suggest the spray. I applied brown earth 6 to either side of the main wave to allow the wave to stand out more emphatically, as well as to the other rocks and foreground. Finally I used the square edge of a white Conté crayon to add the finishing touches – in this case, rhythmic detail to the waves and a few 'flicks' for seagulls near the centre of interest, to give the painting scale and some life form.

The Finished Painting

Porthcothan
35.5 x 53.5cm (14 x 21in)

In this demonstration I hope that I have shown how some of the qualities of watercolour and pastel can be fully exploited. My aim was to try and capture a sense of place – the mood and light of this particular stretch of coastline. I believe that the same sense of urgency should be applied to a studio painting as to one done *in situ*. Creating a sense of excitement, also of risk-taking and spontaneity in the work is vital – particularly with a subject like this. It is so easy to 'fiddle' and to overwork a painting if you are not careful. Painting is a personal translation of what you see and feel. Experiment, and soon you will have your own ideas on how best to use watercolour and pastel together.

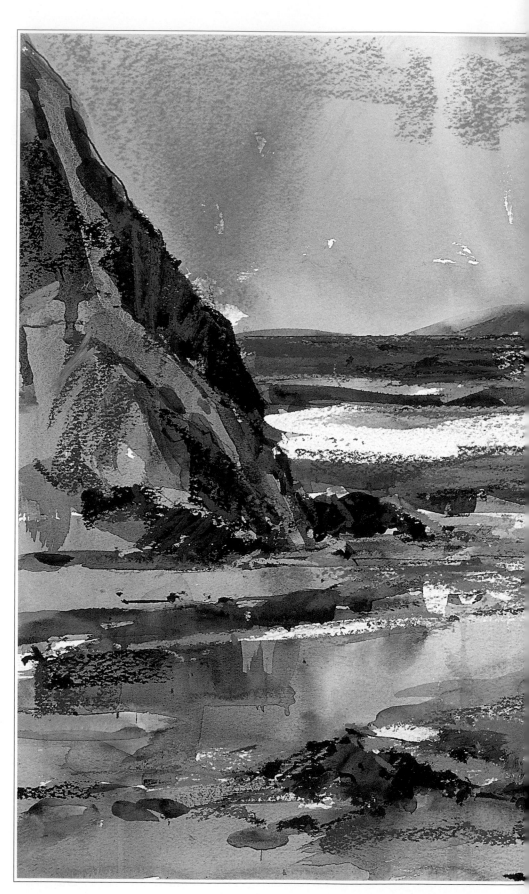

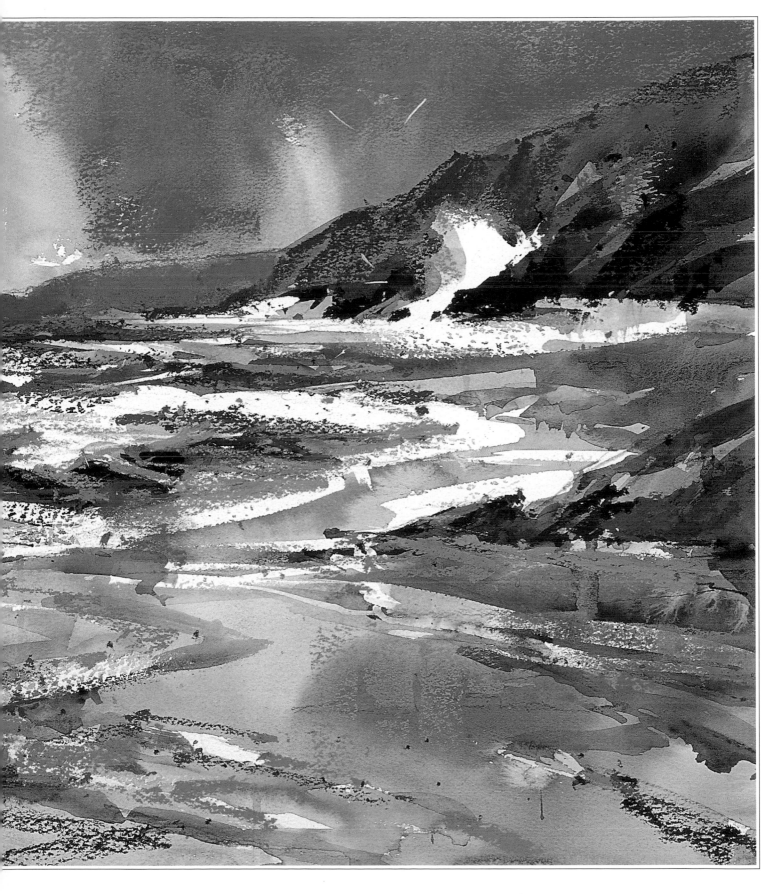

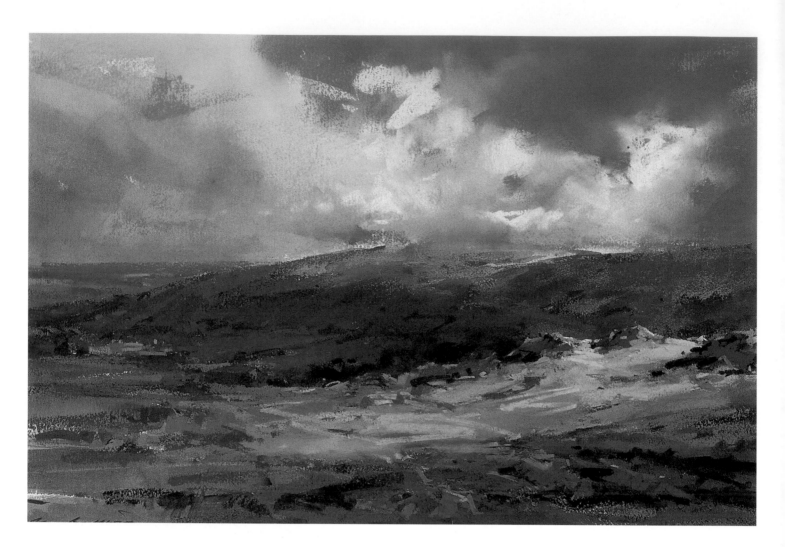

Above: **Sunlight and Shadow, Dartmoor**
35.5 x 53.5cm (14 x 21in)
The play of light and shade on this landscape, and the
transient nature of skies lend themselves wonderfully
to using a combination of watercolour plus soft pastel.

Opposite: **Rocks and Surf,
Talland Bay**
53.5 x 35.5cm (21 x 14in)
This is one of my favourite painting spots in
Cornwall. What excites me particularly is
that it is always changing, and as a motif it
offers up countless ideas for painting

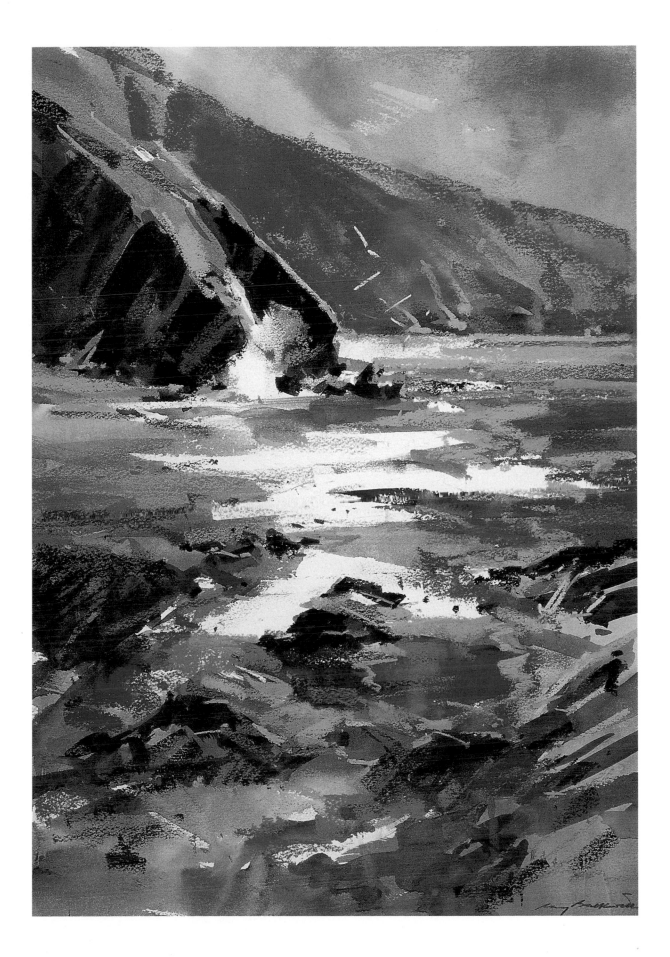

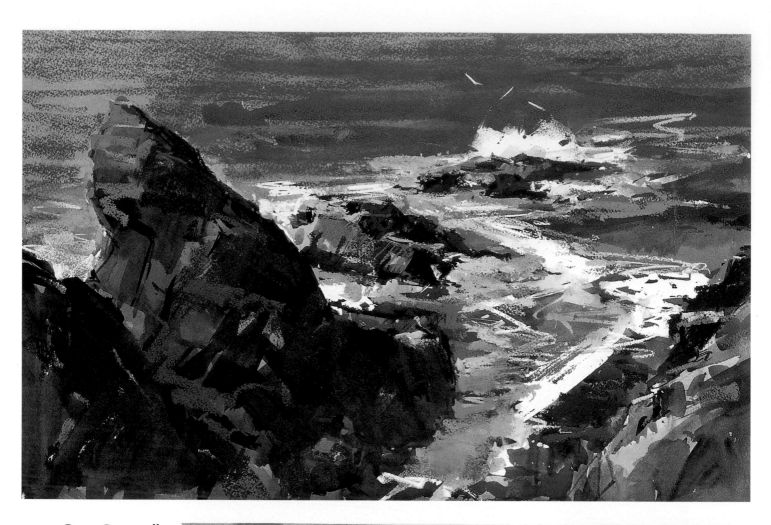

Above: **Cape Cornwall**

35.5 x 53.5cm (14 x 21in)
The first moment of emotional response to a scene is very important, and as I rounded the coast path at Cape Cornwall, this was something I simply had to capture.

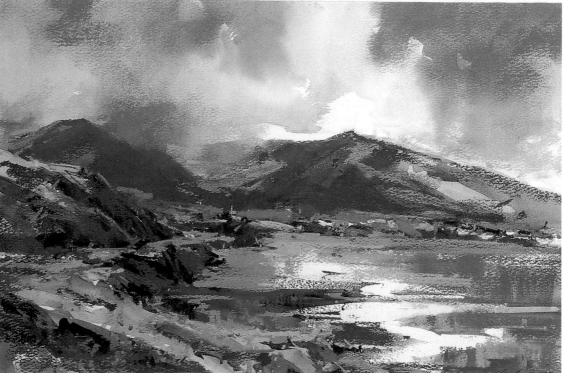

26

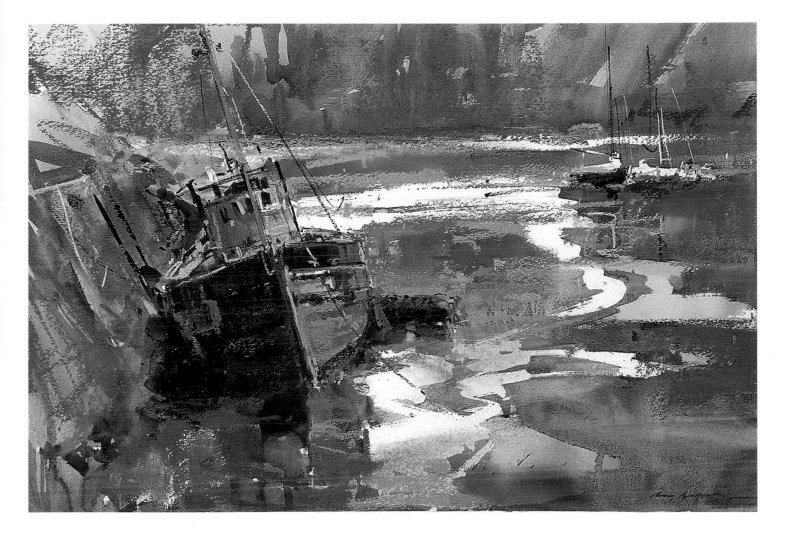

Above: **'Providence' at Douarnenez**
35.5 x 53.5cm (14 x 21in)
This plein-air *painting was done on a*
recent trip to Brittany in the north-west of
France. The blustery day made working very
difficult, but I found the windswept water
challenging to paint.

Opposite below: **Connemara Sky**
35.5 x 53.5cm (14 x 21in)
With its mountains, big skies and water,
Ireland provides the landscape painter with
an endless supply of inspiring, and often
surprising, source material for compositions.

Watercolour *plus* ... Textures

What I like most about watercolour is its unpredictability. The random effects that occur through letting water-based paint 'do its own thing' allow the possibility of being really creative, and I search for ways of increasing this unpredictability. One way to do this is to introduce items into the wet paint that have the effect of disturbing the washes, by dispersing or absorbing some of the liquid pigment – materials found around the house as well as masking fluid, salt and candle wax.

The advantages of using these effects are that the resulting textures enrich the surface of the paper; they have a unifying effect, in that the same textures can extend over different parts of the picture; they can help to capture the essence of a scene; they give me a freedom to explore the abstract and compositional qualities of the painting without worrying about specific effects. Ultimately, textures provide an opportunity for the image to develop into a completely original and individual painting.

MIKE BERNARD

Early Morning Light, Polperro
54.5 x 72.5cm (21½ x 28½in)
In this atmospheric fishing village scene I wanted the cottages to melt into each other and be described with a minimum of detail – a case of 'less is more'.

28

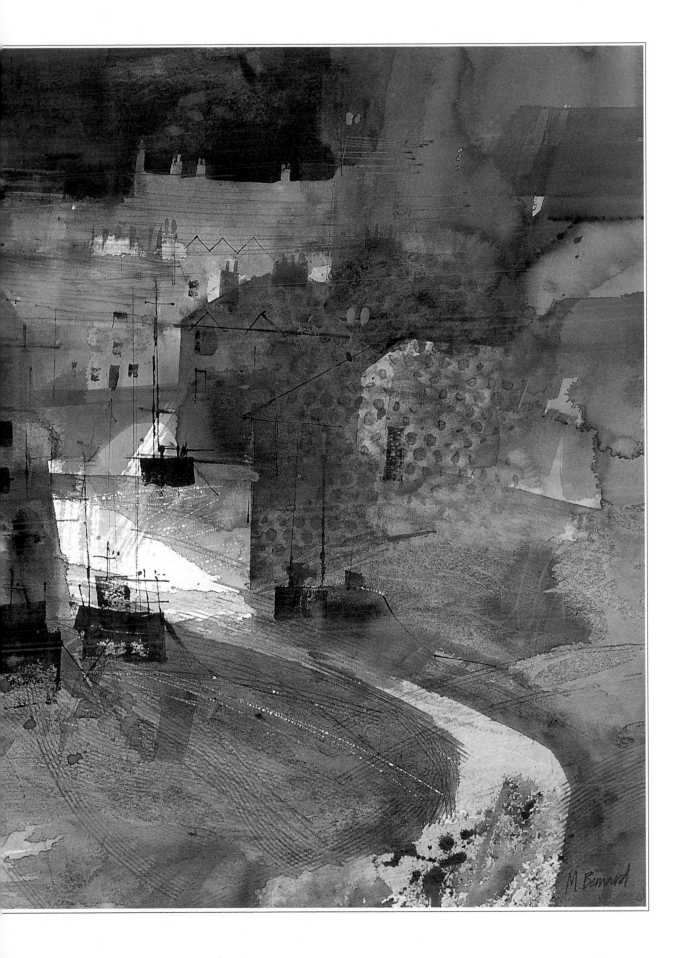

Materials

Paper

I usually work on a 600gsm (300lb) paper, because I often start a painting by flooding quite a lot of water onto most of the surface. The paper can be Rough or Not, and I am happy to use any good quality watercolour paper because the techniques I use are mainly experimental, and different makes of paper can cause different effects – which I can then exploit as I go along.

Paints

I generally use Winsor & Newton artists' quality watercolours, applying them strongly and allowing them to mix on the paper. After an initial application of two or three colours over most of the surface, I then begin to press the texturing materials into the wet paint, sometimes applying more paint on or under the materials when they are in place.

Texturing materials

There are a number of proprietary items on the market that are designed specifically to create textural effects; these include masking fluid, texture medium, blending medium, iridescent and granulation mediums, texture and

Left to right: *corrugated card; synthetic sponge; sponge cloth.*

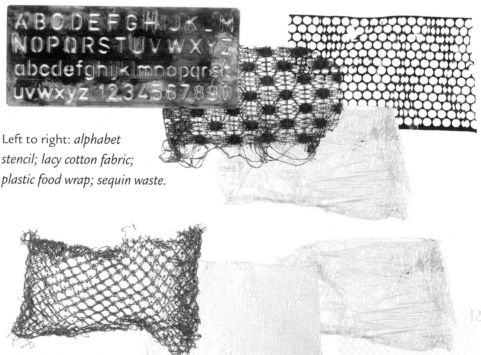

Left to right: *alphabet stencil; lacy cotton fabric; plastic food wrap; sequin waste.*

Left to right: *netting from bag of fruit or nuts; nappy (diaper) liner; plastic sealed air wrap; curtain netting.*

impasto mediums and preparations for lifting paint off the surface.

In addition it is possible to use a whole variety of materials that can be readily found in most households – in fact, you can use anything that will disturb a wet wash. I use the items shown here on a regular basis.

You can also use such household items as salt (all grades), fabrics, paper and plastic doilies, kitchen utensils, coins and flat washers, candle wax, feathers, construction toys – the list is practically endless.

Techniques

Pressing in objects

My primary technique is to press the items shown on this page and to the left – and others – into a wet wash with plenty of pigment in it, and then to let it dry naturally overnight, before removing the item. As an alternative technique, I brush or apply paint onto items such as coins or washers, and then press them into the surface and remove them before the paint has dried. This produces a 'printed' effect.

Left to right: *coins, potato masher, paper clips, washers, drawing board clips; children's construction toy parts; leaf and feathers; uncooked dried spaghetti.*

Left to right: *sequin waste; plastic food wrap; lacy cotton fabric; alphabet stencil.*

Left to right: *curtain netting; plastic sealed air wrap; nappy (diaper) liner; netting from bag of fruit or nuts.*

Left to right: *linoleum roller; sponge cloth; (above) synthetic sponge, (below) wood, card, netting; (above) fingertips, corrugated card, (below) cardboard tube ends.*

Using resists

I also use more 'traditional' methods of producing textures, such as applying resists like candle wax or masking fluid before painting or texturing, and then rubbing the fluid off when it has completely dried. I like to use resists when a first wash has dried, so that I can build up layers of revealed texture.

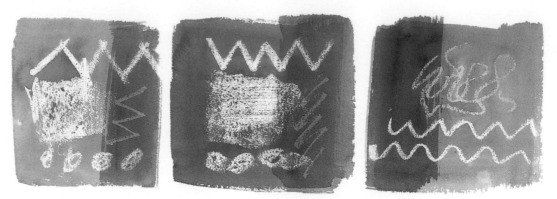

Left to right: *candle wax; candle wax; oil pastel and candle wax.*

Left to right: *masking fluid; masking fluid applied with card, brush, dip pen and sponge.*

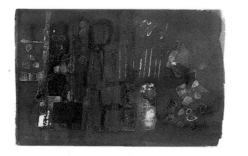

Using proprietary mediums

Art-material manufacturers produce many different mediums for creating textures.

Left to right: *texture medium mixed with watercolour; impasto medium mixed with watercolour and applied with a palette knife;*

lifting preparation applied to paper and allowed to dry so subsequent washes can be lifted off; granulation medium mixed with staining colour.

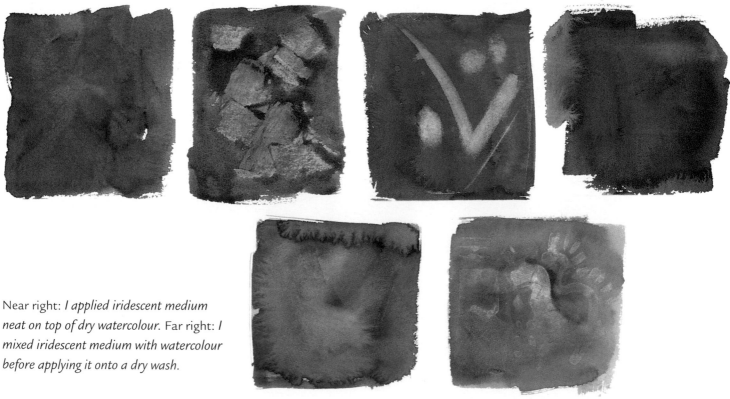

Near right: *I applied iridescent medium neat on top of dry watercolour.* Far right: *I mixed iridescent medium with watercolour before applying it onto a dry wash.*

Dropping in materials

In each of these cases I drop, rather than press, the material onto the wet watercolour wash, then let it dry completely before blowing or gently brushing it off; I allow the surgical spirit to dry on the surface.

Left to right: *rice; kitchen salt; surgical spirit.*

Drawing with materials

When you work with textures, even the act of drawing becomes part of a textural process. For drawing I use not only traditional tools, such as a dip pen, but also less orthodox ones, such as pieces of cut mount card and combs, which I may also press into wet washes as described on page 31. Nothing is ever wasted!

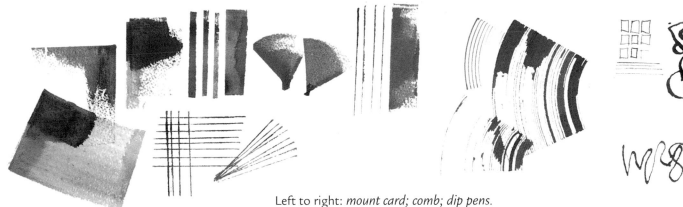

Left to right: *mount card; comb; dip pens.*

Spattering and blowing paint

Applying paint to a surface without the tool touching the paper is a random technique, in that you cannot be sure exactly where each drop will land and how it may spread or move before drying – and that, of course, is the exciting part. In the examples shown below, I used the stiff, short bristles of an old tooth-brush and the longer, softer ones of a brush for spattering, as well as blowing paint through a plastic straw.

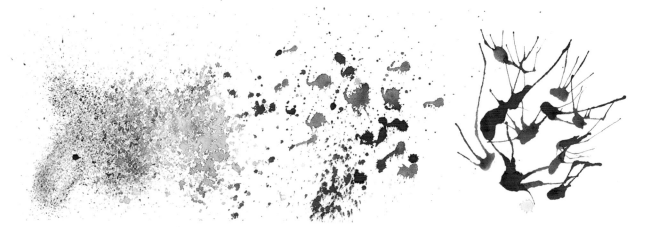

Left to right: *toothbrush; large paintbrush; plastic straw.*

33

PROJECT:
Harbour Scene

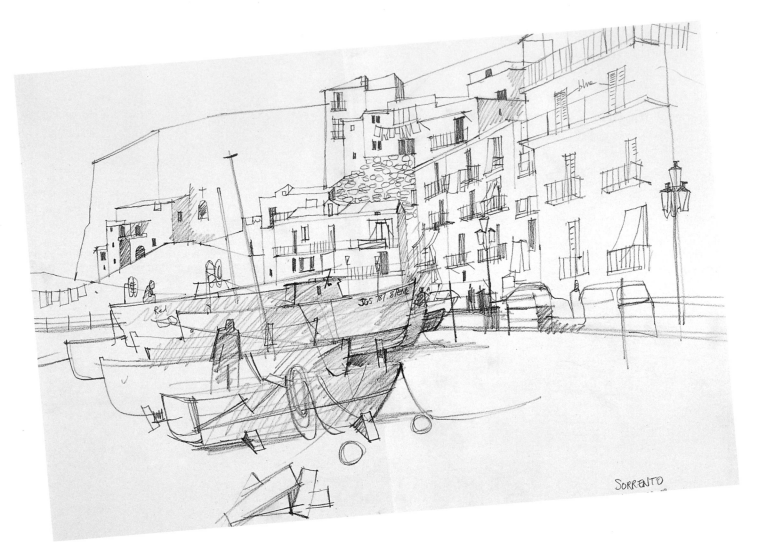

I am attracted to harbour scenes because they offer me the opportunity to develop a semi-abstract design of shapes and colours that can be pleasing to the eye, while not departing entirely from the conventional representation of the scene. The repetition of shapes – boats, buildings, chimneys, cranes, windows, doorways, masts, buoys, ropes and so on – offers endless scope for creating patterns and rhythms that are exciting to me and, I hope, the viewer.

The first stage is an underpainting on which I can create all sorts of

Above: *I drew this sketch on the spot in the old harbour in Sorrento, Italy. It is fairly representational, but it acts only as a starting point for the painting, and I put it away after a while, so it did not influence the development of the painting. I referred to it again at the end, to select some details.*

textures, either tentatively suggesting the subject or completely randomly – and also using materials that are generally regarded as being foreign to watercolour. I work with the paper flat, and have to allow plenty of time for the washes to dry naturally.

Materials

- 56 x 76cm (22 x 30in) sheet of 600gsm (300lb) Not Saunders Waterford watercolour paper
- Brushes:
 5cm (2in) varnishing
 1.2cm (½in) flat watercolour
 1.2cm (½in) hog bristle
- Spray bottle and water
- Bamboo pen
- Craft knife
- Watercolours:

 indigo

 Winsor violet

 cadmium red

 brown madder

 Winsor orange

 quinacridone gold

- Cotton netting
- Nappy (diaper) liner
- Plastic sealed air wrap
- Plastic food wrap
- Alphabet stencil
- Coins
- Washers
- Salt
- Fabric mount card cut into 10cm (4in), 7.5cm (3in), 2.5cm (1in) and 1.2cm (½in) widths
- Linoleum roller

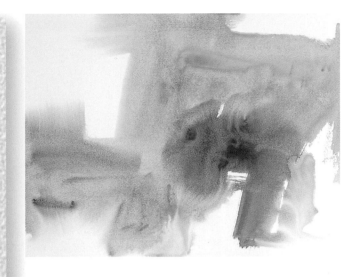

1 I started by flooding water copiously onto the paper, using a spray bottle and a 5cm (2in) varnishing brush to spread the water, but leaving one or two white areas of paper. I then used the same brush to apply quinacridone gold, Winsor orange and brown madder in a fairly random manner.

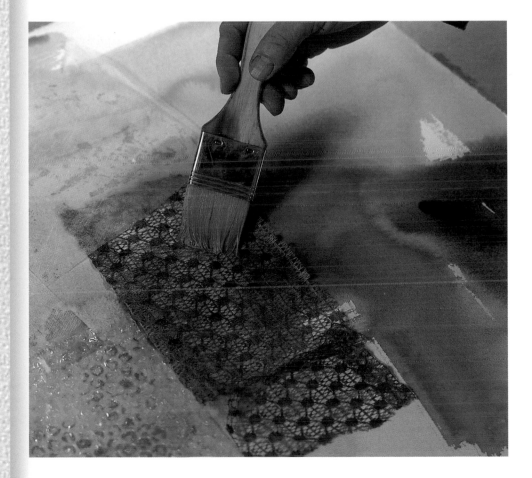

2 After applying an area of Winsor violet, I then pressed cotton netting, nappy (diaper) liner and plastic sealed air wrap into the wet paint – I soaked the absorbent materials first to encourage them to lie flat on the surface and absorb the paint. I then applied more paint through the netting. At this stage, the effects are unpredictable.

3 I pressed plastic food wrap onto the area of Winsor violet, and then lifted the edges of the wrap a little and applied more violet so that the paint ran into the creases under the sheet of wrap. I pressed the wrap down onto the paint again.

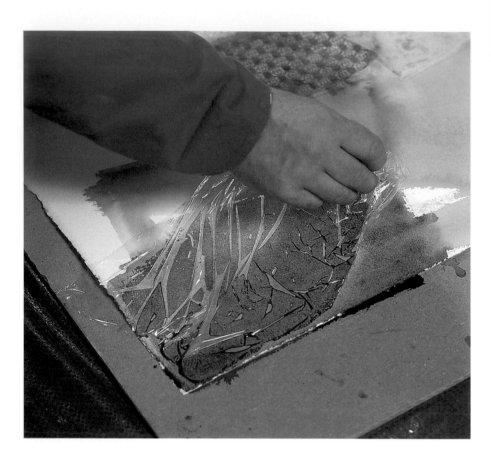

4 I applied an area of cadmium red to the bottom of the painting and pressed an alphabet stencil into it, before flicking on some more red with a 1.2cm (½in) flat brush. I selected some coins and flat washers and pressed them into the wet paint, and then sprinkled salt onto those places where I wanted the colours to be absorbed. I then left the painting to dry thoroughly overnight.

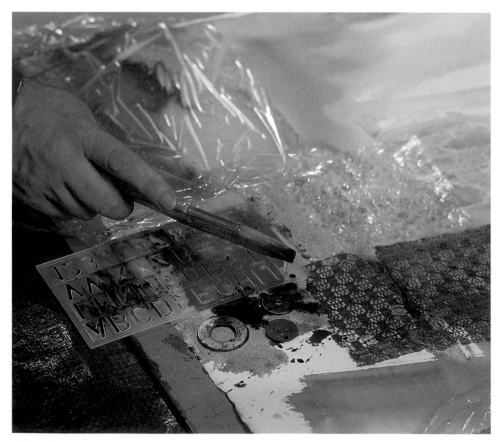

5 So as to be able to start the second stage of the painting, basing the composition on my initial sketch, I removed the materials and brushed the salt off the dry surface. Using indigo on the 5cm (2in) brush, I started the roof line. I painted the negative shapes wherever possible, preserving the effects of the texturing – subtle variations of colour from the underpainting occurred when I applied the secondary washes.

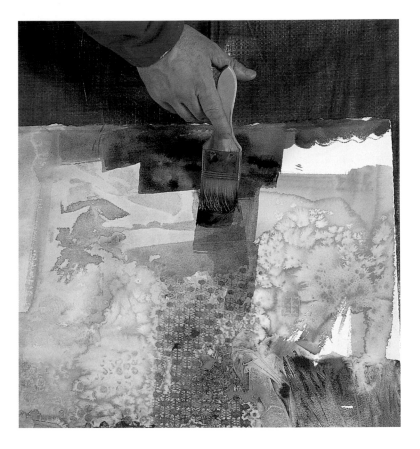

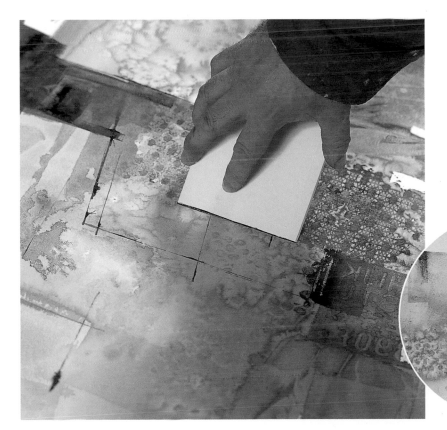

6 I cut a piece of mount card to 10cm (4in) wide and used it to apply brown madder to establish the lines of the buildings. You need some confidence in your drawing skills to do this effectively, as well as an awareness of perspective, so it is worth practising on a piece of scrap paper.

Inset: For variety, I then sprayed water over some of the lines to soften and blur the edges, before dragging the mount card in places to create more solid areas of colour.

7 To suggest the texture of stonework on a wall, I cut a strip of plastic sealed air film and applied brown madder to one side, and then stamped it onto the paper to make a printed effect.

Inset: I reapplied cadmium red to the bottom of the picture, then pressed cotton netting into it to suggest fish nets hanging from the sides of a boat. I then applied more red through the netting.

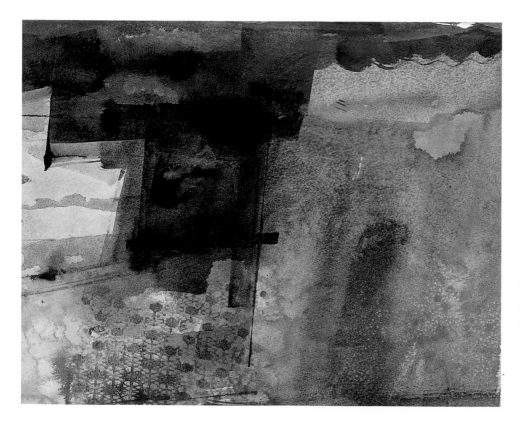

8 I brushed Winsor violet onto the top right area to frame the picture and direct the eye to the focal point of the boat. I next applied big washes of purple over orange, contrasting warm and cool colours and hard and soft edges – I used directional brushstrokes with both the small and large brushes, splashing on the colours and pushing and pulling them over the paper. I then used a 1.2cm (½in) piece of mount card to apply lines of quite opaque cadmium red.

PROGRESS REPORT

It was now time to take stock, as the image was beginning to emerge quite strongly. Because the right-hand red shapes were starting to look like the awning of a café, I decided to ignore the sketch and make them a feature without distracting from the boat, the main focal point. The next stages would be to develop a pleasing pattern of lights and darks, colours and lines, and to enhance the rhythmic qualities of the textures by repeating shapes in different sizes, attitudes and colours. Rather than simply copying the original scene, I was now in a position to go on with the painting's random evolution: if a texture or shape suggested something, I could utilize it for itself, instead of being shackled by the sketch.

The left-hand side fades into the distance, and the activity is now concentrated on the right side

Cadmium red on the boat creates a sense of balance with the café awning, and helps to keep the eye moving

The textures show through subsequent washes, and can be used to build up repeated shapes

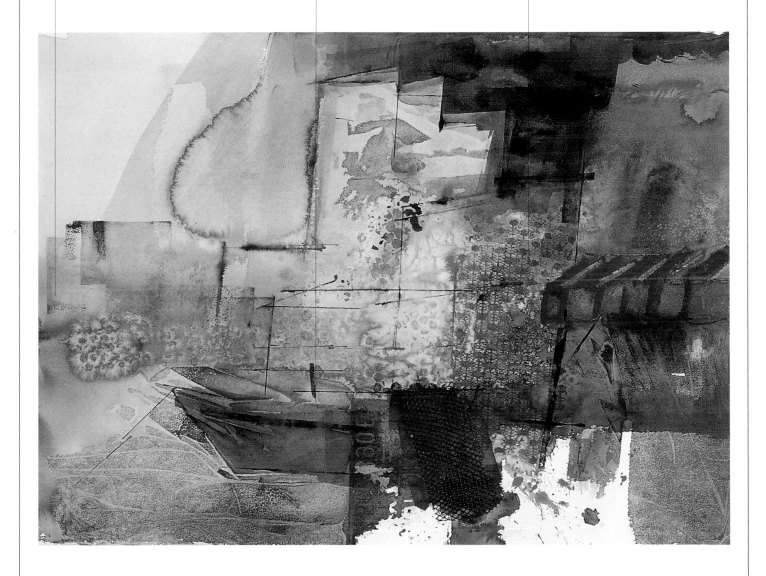

9 I sharpened a stick of bamboo into a point and used this to add some of the smaller details on the buildings. I used the 1.2cm (½in) brush and a 2.5cm (1in) strip of mount card to draw in the larger details. Using different implements in this way helped to add to the variety of marks and interest – the more spontaneous the mark, the better.

Inset: In order to stylize the figures and make them simple and economical, I drew them in purple with the pieces of mount card.

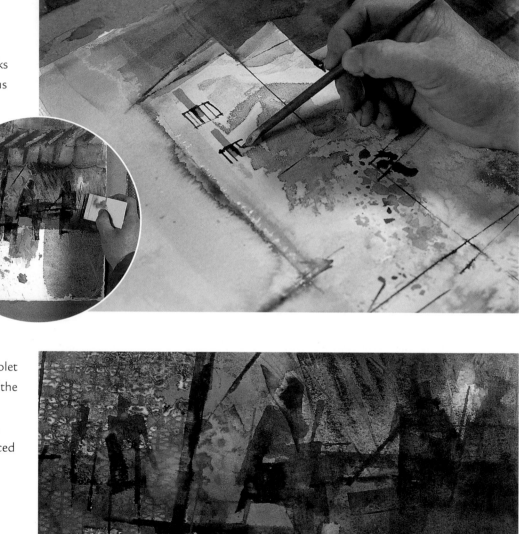

10 I coated netting cotton with violet and then purple paint, placed it on the paper and then pressed it into the surface with a small linoleum roller. This extra layering of texture produced a three-dimensional effect.

Inset: To give more texture to the stonework of the buildings, I applied quinacridone gold and Winsor orange with my finger.

11 To bring more emphasis to the boat in the focal area, I washed out some of the paint around it using a 1.2cm (½in) hog-bristle brush dipped in clean water – lightening behind the boat to bring it forward, softening some of the edges on the near side, and suggesting a light rope in front of the dark netting.

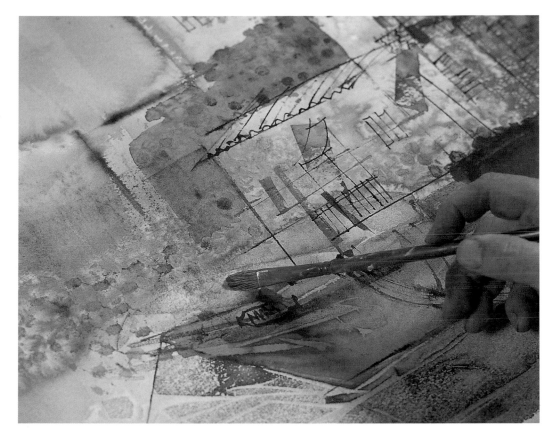

12 I added some printing, using coins and washers dipped in cadmium red to suggest buoys or floats. To add to the variety of marks, I only partially dipped some of the objects before pressing them onto the paper.

Inset: I scratched out a few lines with a craft knife to bring some light back into the picture, using a piece of mount card as a straightedge where required.

The Finished Painting

The Marina Grande, Sorrento
53 x 71cm (21 x 28in)

The finished picture shows details added near the end of the painting process – a line of washing, for example, to give the impression of day-to-day life. At the beginning of the painting I aimed to create a pattern of shapes, using the sketch as a starting point, but evolving the picture as I went along, almost as if it had a life of its own. Many of the effects were accidental, or at least not planned, and it was exciting to see how they could be developed into something that was more representational – the café, for example. Even so, it is surprising that although the result does have many abstract qualities, working with such an approach can still often capture the essence of the original subject.

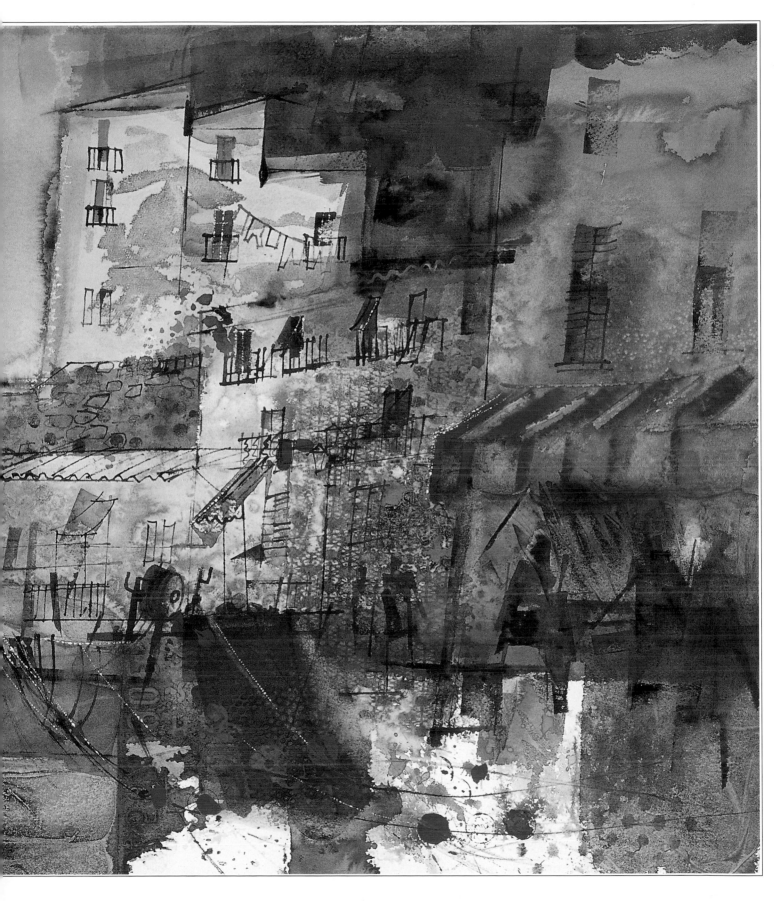

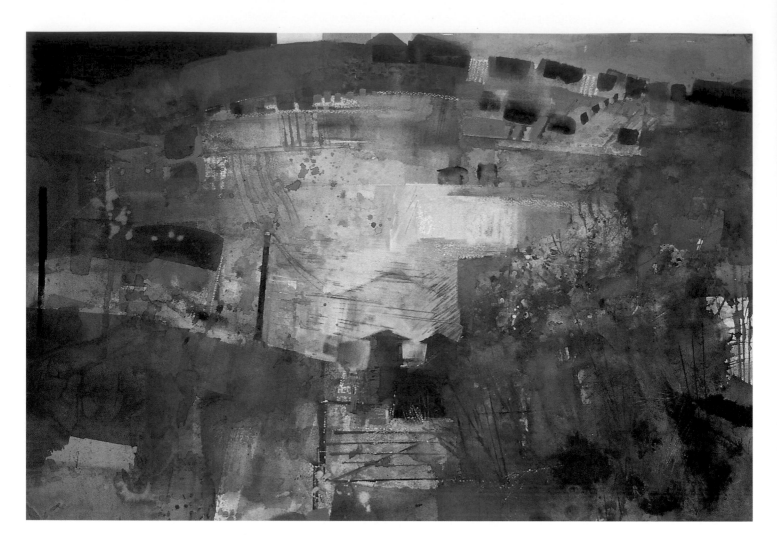

Patterned Landscape, Hampshire
54.5 x 71 cm (21½ x 28½ ins)
This painting is very much a composite of memories and odd sketches of the Hampshire landscape near my home. My objective was to capture some of the pattern of the landscape and the sense of how the scene opened out when viewed through the farm gateways and the openings between the trees and hedgerows.

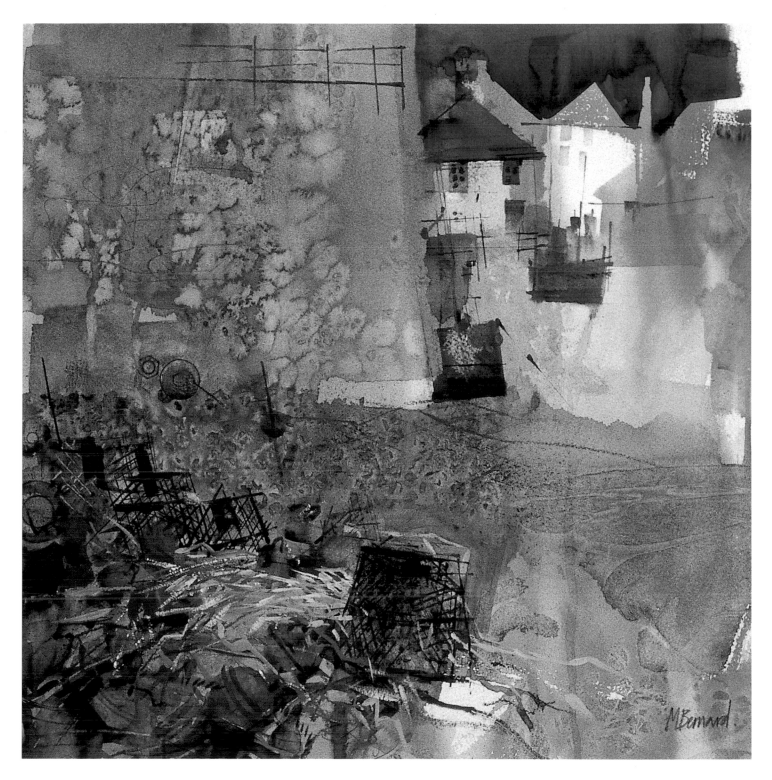

Harbour Wall and Cottages
54.5 x 54.5 cm (21½ x 21½ ins)

At a local art society I was demonstrating how to achieve certain textures using salt, plastic wrap, sand, spatter and so on. At this point I had no image in mind – but many weeks later I studied the textured surface, and decided to cut the paper into two and develop two different pictures from my imagination. The resulting images derived purely from the shapes and textures that were on the paper.

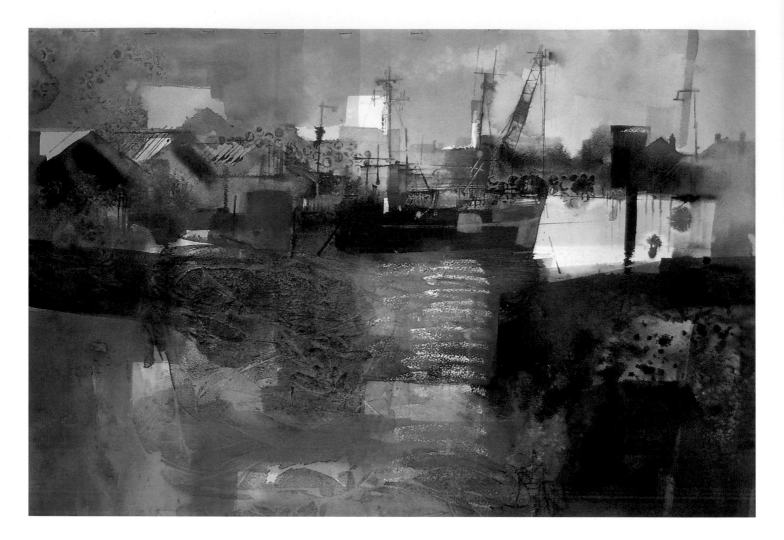

Portsmouth Harbour

53.5 x 71cm (21 x 28in)

This painting was based on a quick sketch made while waiting to board a car ferry. During the application of random washes an area of light developed on the right-hand side of the picture, and this, together with the red/orange boat, acted as my focal point. I subdued the sky by adding a little white gouache to the final wash.

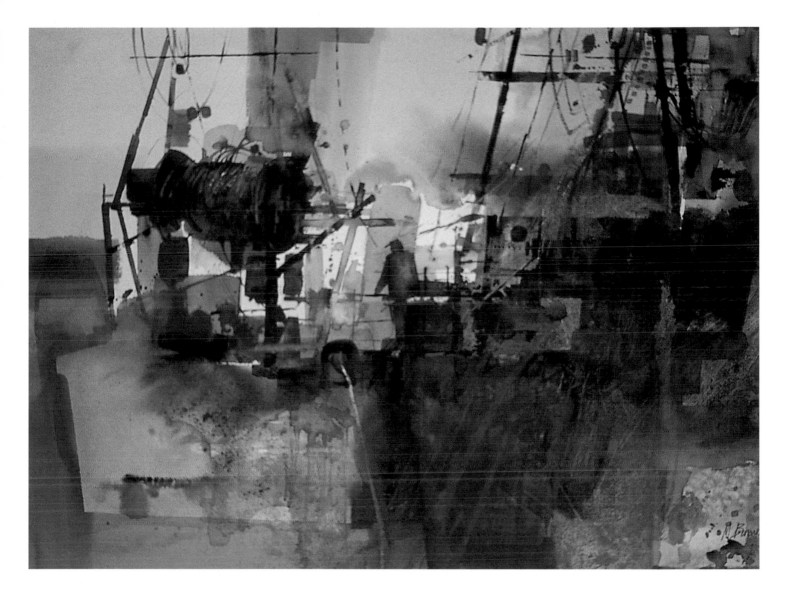

The Red Fishing Boat

60 x 71cm (23½ x 28in)

For some, subjects like fishing boats or farm machinery are not attractive objects to paint, or they may be intimidated by the complex details and shapes. I really enjoy them, as they offer a wealth of abstract shapes and colours — here, the fishing boat offers wonderful negative shapes created by the masts and rigging.

Watercolour
plus . . .
Gouache

The interesting combination of watercolour plus gouache gives a really broad range of possibilities because they are from the same family of paints and intermixing (in many possible proportions) is perfectly feasible. The translucency of watercolour can be set against the opacity of gouache to contrast against one another in the same way that light contrasts against dark.

In terms of painting, gouache is extremely versatile and easy to use, with a range of properties that moves from the fluidity of watercolour to the impasto of oil painting.

Its greatest asset is probably its distinctive matt, chalky effect, which when dry sets it apart from other paints with its ability to reflect light more than watercolour. Unlike watercolour, white plays an important role in mixing gouache (also known as body colour), and its covering power means that you can adapt or change the painting (or rectify your mistakes!) as your work progresses. This freedom to rework means you don't have to be as technically restrained as in watercolour alone, but you can be responsive to your ideas as the painting develops.

MARTIN DECENT

Silver Birch Wood
30.5 x 40.5cm (12 x 16in)
This painting was completed en plein air, as the location had benefits — the site was dry, level and very sheltered, while being lightly and evenly shaded.

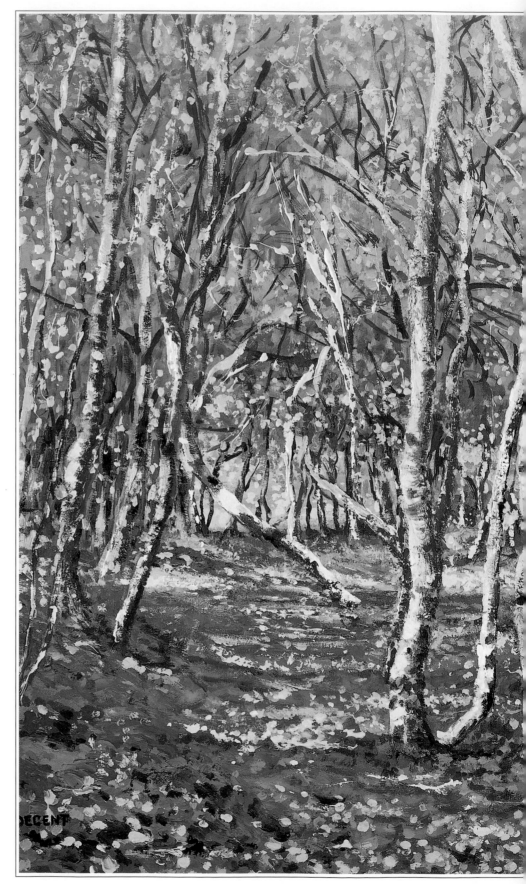

48

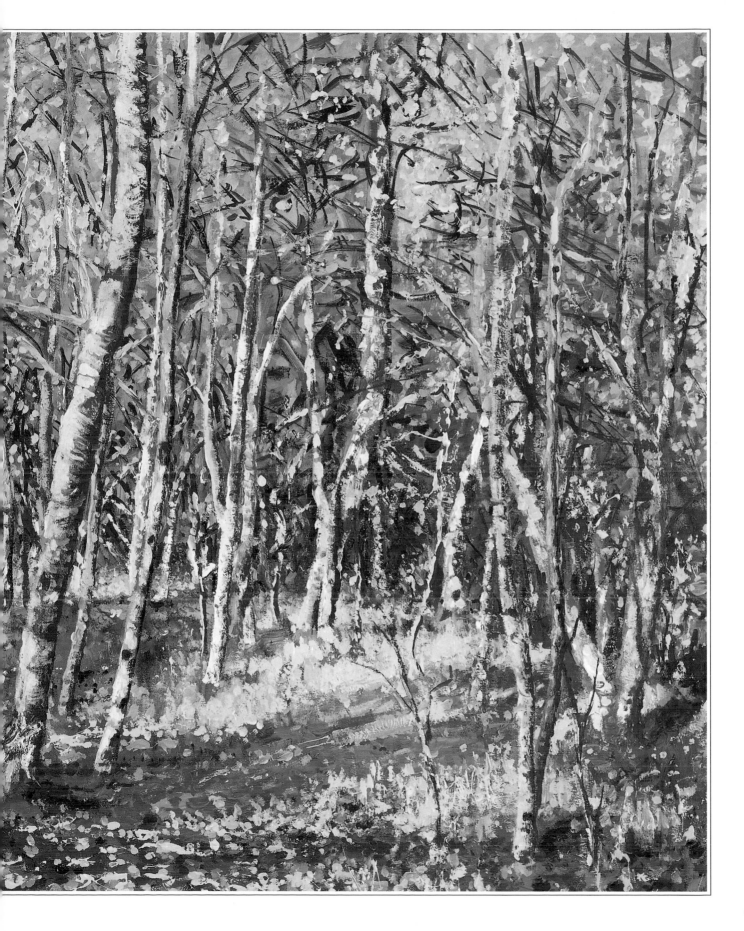

Materials

Techniques

Watercolours

I prefer to use watercolour in tubes because they have a consistency of handling that is similar to gouache. When painting with watercolour and gouache together, I think it is important to have the opportunity to mix the two paints easily – and solid pans do not readily give this option. I tend to paint with watercolour first, then gouache, because this gives you the flexibility of reworking your composition. Watercolour is always absorbed into the paper, whereas with gouache you have the option to use differing thicknesses and an opacity that can be used to overlay watercolour.

Supports

When painting in watercolour and gouache I use the papers one would expect to use with watercolour. A good all-rounder is Bockingford 300gsm (140lb), particularly when the intention is a watercolour with some gouache. I find Rough paper better for a primarily gouache painting with watercolour as underpainting, because the tooth of the paper complements the layering of gouache.

If painting only in gouache, there are opportunities to use different materials as paint supports. A coloured mountboard card is ideal because gouache has the ability to completely cover the underlying colour. This can be used to great effect by leaving the underlying mountboard colour to show through as highlighting, or by adding a tone to the overall work similar to pastel on a tinted paper.

Gouache

I use Winsor & Newton Designers Gouache, in which each colour is categorized in terms of cost, opacity, staining and permanence. The first three categories can be learnt through experience in handling gouache and are not fundamentally critical – and if you are sensible with permanence, it will not be a problem. Permanence of pigments is rated as AA, A, B and C: I use only AA and A, which are highly permanent and encompass the majority of the colour range. The B and C codes are distinctive colours that have a brilliance which will fade. There are two types of white: permanent and zinc. Basically zinc white is lightfast and used for mixing, while permanent white is totally opaque but should be used solely as a white.

Within the colour pigments there are degrees of opacity and staining of overlaid colours.

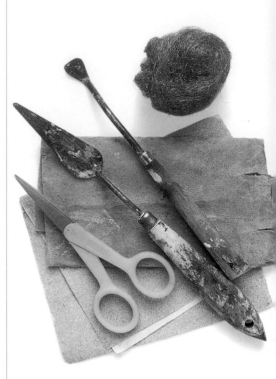

Watercolour plus gouache is a slightly different technique to the others featured in this book because gouache is more closely related to watercolour than the other mediums. Remember that gouache is an opaque watercolour and the amount of water mixed with the colour will result in different effects. This range starts with thin, overlaid flat washes using plenty of water, and ends with a palette knife impasto created using no water but a binder such as Aquapasto. Essentially, the range of possible applications (or reworking) is broader with gouache than with watercolour. This does not degrade the beauty of watercolour painting, but rather will enable you to broaden your experience and knowledge of methods available, by freely using both watercolour and gouache to produce a finished painting that you consider satisfactory.

Mixed watercolour and gouache

You can, for example, mix watercolour (yellow) and gouache (blue) to produce a secondary colour midway between the wash of watercolour and the flatness of gouache. This is useful when you wish to subtly alter a watercolour without the obvious change to 'mixed media' that the opacity of gouache used on its own can imply.

Wet-in-wet

Watercolour and gouache can be merged together using a wet-in-wet technique. This is particularly useful when creating light and shadow effects in, for example, foliage. The shadow areas are more opaque if gouache is used to darken those areas, and this automatically enhances the lighter, transparent watercolour paint.

Impasto relief

Here, the yellow water-colour wash is dabbed with kitchen paper to give a background pattern. Using a palette knife, gouache mixed with impasto medium gives relief and texture to the painting without the risk of cracking – very useful when painting cliffs or rock reliefs. Sand can be added to give texture if appropriate.

Light over dark

Here, Naples yellow is laid over a darker violet and then removed with the handle tip of a paintbrush. This allows the base colour to show through and demonstrates the covering power of gouache in painting light over dark. Gouache can enable you to rescue a painting that has become too dark or simply does not look satisfactory. In a broader sense it demonstrates the ease of highlighting with gouache, which can be done towards the end of a painting without the rigid planning necessary using only watercolour.

Scraping back

Many effects are possible by scraping off gouache to create patterns or outlines. For a smooth drawing effect this should be done within an hour of laying down the gouache, when it has dried but is still malleable. Here, permanent white has taken the area back to its original card tone, which could then be repainted or left as a flat tone. The lines are from an underlying wash of colour.

Contour patterns

Here, five layers of gouache are laid one on top of the other, with a few minutes drying time between the application of each layer.

Because gouache is a physical layer of paint, it can be removed by lightly rubbing with wire wool to create contour patterns of colour.

Overlaying colour

The simple overlaying of gouache will give a vibrant secondary colour. Because the paint is fast-drying compared to watercolour, there is a minimum bleed of colours. The high chromatic key of gouache means its introduction into watercolour can highlight any area you wish to be a focal point.

Scumbling

Here again, a lighter colour overlays a darker colour. The gouache is dabbed on with a crumpled piece of tissue paper, and the process can be repeated to create a complex pattern that allows parts of each layer to remain visible. This is a useful technique for creating clouds in clear skies, where the final effect is blended with a moist cloth.

PROJECT:
Moorland Scene

I live in the beautiful but untamed landscape on the border between South Yorkshire and the Derbyshire Peak District in the North of England. Half an hour's walk from my home brings me to Stanage Edge, a five-mile outcrop of gritstone that I find more appealing than the cultivated and controlled valley hundreds of feet below it.

To paint in such a place is extremely difficult and impractical because of the almost

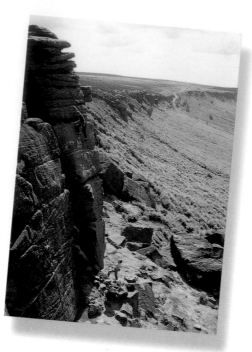

Above: *Photographs are an easy and practical compromise for recording the location, besides which they enable me to paint all the seasons and all weathers.*

constant buffeting of wind on the exposed edge. Postcard sketches taking five minutes are possible and useful in order to make notes for colour references on the spot. I sometimes make a continuous video recording (1–4 hours recorded using a tripod) of a view and play it back in the studio. The changing light on a landscape, through cloud shadows and the sun's movement or the onset of rain, are all uncertainties that

painters can dread – however, they can become a positive record when you know those moments in time are not completely transitory or lost but can be analysed as you require, through replaying. The automatic recording of the sound is also an important and unexpected bonus.

There are many ways in which gouache can be used, from washes similar to watercolour, to impasto work like oil paint. In this project I have chosen a lesser known use, where the gouache is used without adding water, except moisture left on the brush after cleaning.

I paint using a large vertical board fixed to my studio wall with the support (here, a piece of white mountboard) stapled along the edges and corners. Doing this gives me a totally rigid base to work on and to push against if scraping back later. I always paint standing up, or rather walking around, looking at the painting from a distance. I tend to use both watercolour and gouache relatively thickly so that painting vertically is not a problem, and I can judge my progress better than if the painting is on a table top.

Artist's Tips

- If you use watercolour paper and want to use the paint more substantially or to scrape back later, this can cause the paper to waver or warp. I ask my picture framer to drymount sheets or cut pieces of watercolour paper before I paint on them.

- Always replace tops on gouache tubes immediately, otherwise paint will dry out and harden in the tube. Squeeze from the bottom of the tubes when using the paint, and store the tubes on their cap ends.

- Because gouache is opaque it has a high amount of white pigment; this means that your water will quickly become dirty compared to watercolour. In the studio I use a bucket of water (not a jar) for colour mixing, and another bucket for washing brushes.

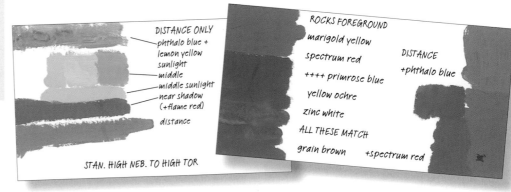

DISTANCE ONLY
phthalo blue +
lemon yellow
sunlight
middle
middle sunlight
near shadow
(+flame red)
distance

STAN. HIGH NEB. TO HIGH TOR

ROCKS FOREGROUND
marigold yellow
spectrum red
++++ primrose blue
yellow ochre
zinc white
ALL THESE MATCH
grain brown

DISTANCE
+phthalo blue

+spectrum red

Above: *I find a series of mixing swatches to be the best method to record my feelings, with a note of paints used and anything else I want to write.*

Materials

- 61 x 61cm (24 x 24in) sheet of white mountboard
- 4B pencil
- Palette knife
- Pair of scissors
- Cloth
- Mixing palette (piece of plastic)
- Watercolours:

 cadmium red hue

 cadmium orange hue

 cadmium yellow hue

- Brushes:
 three 3mm (⅛in) flat
 7mm (⁵⁄₁₆in) flat
 No. 2 round
 7.5cm (3in) decorator's
- Winsor & Newton Designers Gouache:

 lemon yellow

 chartreuse

 permanent yellow deep

 marigold yellow

 flame red

 spectrum red

 zinc white

 cobalt blue

 azure blue

 phthalo blue

 primary blue

 brilliant green

 yellow ochre

 Vandyke brown

1 I drew out the scene very roughly at this initial stage with a soft graphite pencil. This was intended to show the block structure of the composition rather than specific details, and was a reference grid that would subsequently become covered by the painting.

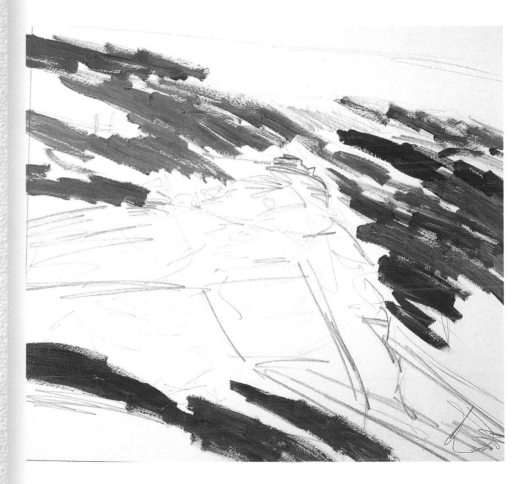

2 I mixed the three watercolours freely across the mountboard, painting from the sunlight direction across the scene even at this early stage. Although the watercolour wash was 'thick', it still ran a little on the vertical board.

3 I used the complementary watercolour to the colour I planned for the finished painting – therefore I made the sky largely orange (complementary to blue sky tones), and used red for the green foliage areas. The use of complementary colours intended to break through the later overpainting adds vibrancy to a colour by placing it next to the secondary colour that is its opposite on the colour wheel.

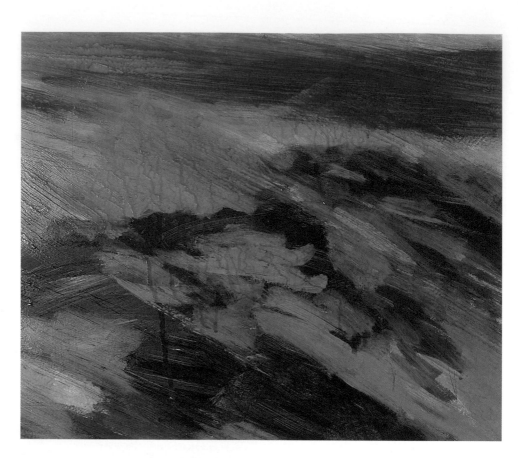

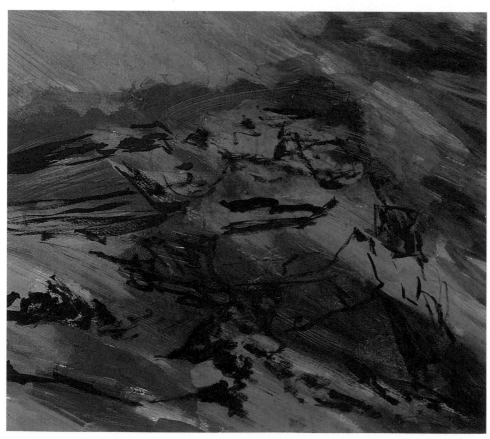

4 To begin the gouache overpainting, I mixed rich cobalt blue with a dab of water and a little zinc white, to lift its tone and increase its opacity and covering power. Using a No. 2 round brush, I drew in the structure of the foreground landscape. At this stage I used the gouache in a consistency similar to single cream.

5 Using azure blue in a similar consistency, I drew in the middle and distance to the horizon; I lightened the tone with a little more zinc white to help with the effect of recession. Rolling the brush between my fingers introduced a randomness more accurate to nature than trying to paint the lie of the land studiously – twisting the brush creates sudden contours appropriate to fields or furrows. I placed arrows on the edge of the painting to remind me of the light direction.

Inset: I now used the paints straight from the tube, starting with a little phthalo blue and lemon yellow, mixed with a little zinc white, for the distant greenery. For the areas in shadow I mixed in a little flame red, following my standard rule for shadows: introduce the complementary colour into the existing colour, then add a little blue to make it darker.

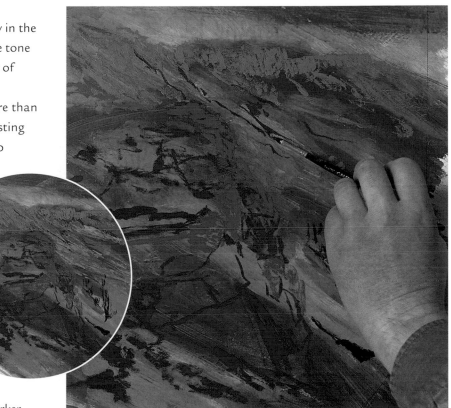

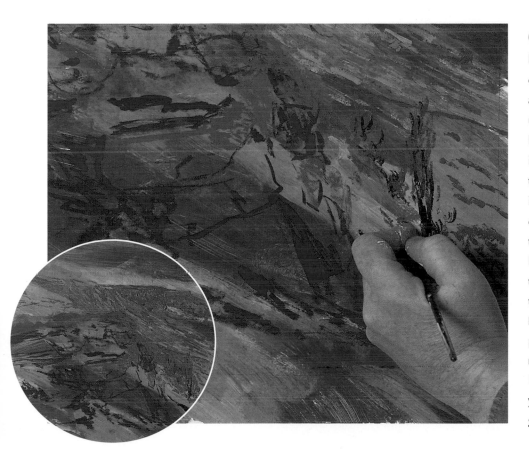

6 With a 3mm (⅛in) flat brush, I made limited, 'dabbing' brushstrokes. This suits drybrush painting and ensures that areas are not the same tone continuously, but undulating, as in nature. (Using several brushes allows you to continue painting instead of stopping and cleaning – I throw the brush into the water bucket and clean it later.) The lighter green was already dry, and I overlaid shadows on it. Even at this early stage the two paints were beginning to contrast, with the transparency of the watercolour against the opacity of the gouache.

Inset: I mixed varying proportions of phthalo blue, lemon yellow and flame red as previously for the shadow areas. In the mid-tones I introduced permanent yellow deep into the mix, with a view to going over with highlights later.

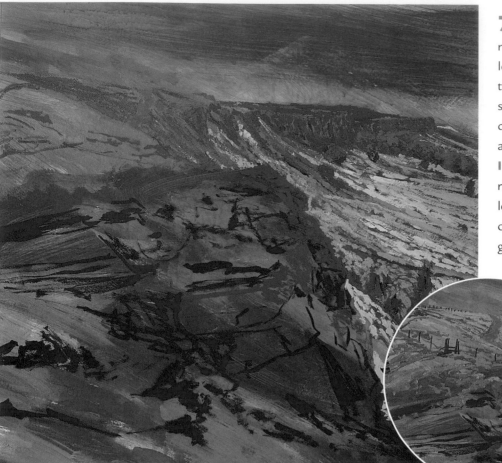

7 Using the colour swatches for reference, I overlaid the distant greenery, leaving the watercolour below showing through. I then introduced the path with spectrum red and zinc white, toned down with a little permanent yellow deep and primary blue.

Inset: While blocking in the top of the ridge to the left middle distance with lemon yellow, brilliant green and yellow ochre to represent the harsher grasses growing on the top of the exposed edge, I left bits of watercolour to break through the gouache as highlighted areas. Using cobalt blue with Vandyke brown, I introduced the outlines of stile and fence on the skyline with broad brushstrokes.

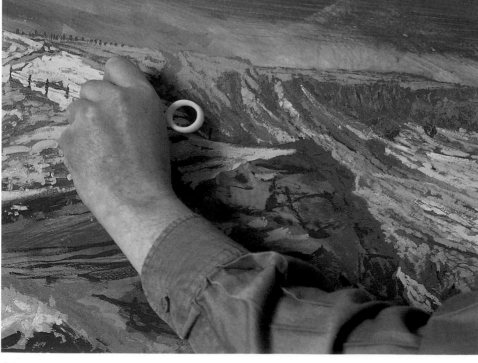

8 For the sunlit areas of the moorland I picked up chartreuse, permanent yellow deep, brilliant green, marigold yellow and yellow ochre with the brush and mixed them on the painting to give a random covering. I then drew in the fencing by scraping through this mix with the point of a pair of scissors.

PROGRESS REPORT

At this stage of the painting, I have allowed the translucency of the watercolour to break through the opacity of the gouache. This helps to hold the picture together and brings a vitality to the painting – this is essential, because colour sensation was my primary motive for painting this subject. Because gouache is a physical layer of paint, it can easily be 2mm (1/16in) thick and will increase when other tones are overlaid. Because of this I concentrated on painting the sunlit areas from the direction of the sun (on the left of the picture frame), and the areas in shadow from the opposite direction. This is because the drybrush stroke action itself creates minute shadows from there being a physical edge to the painting .

The rock outcrop and foreground are painted in warm and hot colours

Everything beyond the near outcrop is toned down to increase the feeling of distance

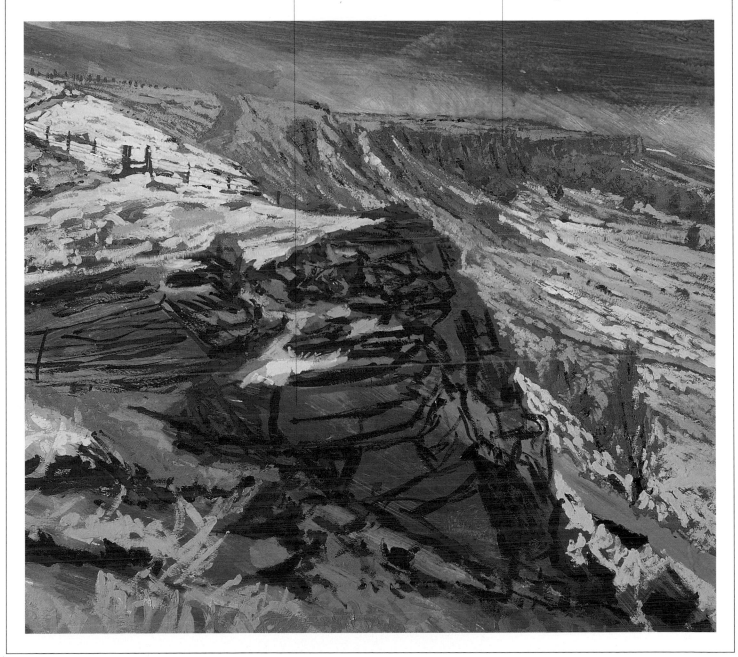

9 I blocked in the rocks with a rough mix of marigold yellow, spectrum red, primary blue and a little zinc white. At this stage I wanted all the rocks to be in shadow, but added yellow ochre to the mix to establish the foreground ones.

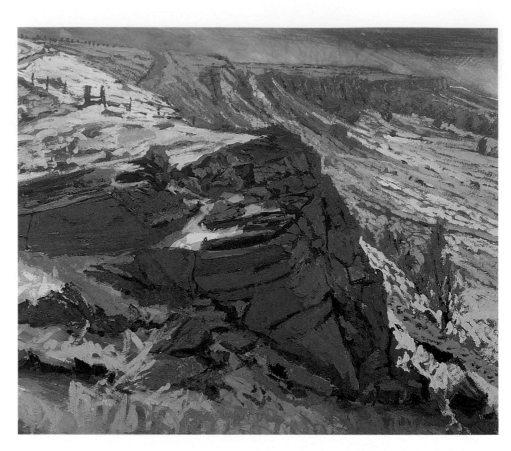

10 For the foreground grasses in shadow I used permanent green with spectrum red and primary blue, plus a little zinc white. I added cobalt blue to this mix to darken the shadows and to increase the structure of the shrubs and trees by the path. Next I introduced primary blue with zinc white and a touch of orange to tone down the foreground rocks and low light edges, and for the shadows to the sides of the paths.

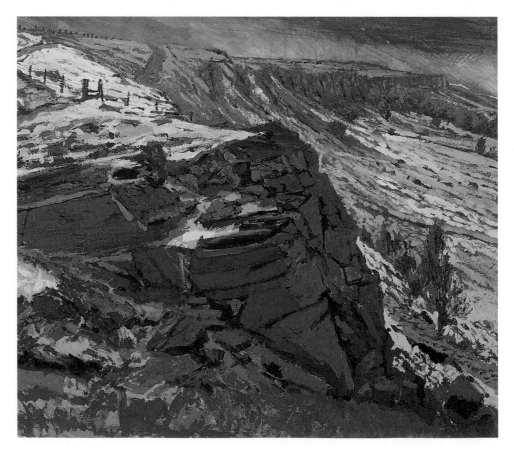

11 For the skyline I used one part cobalt blue to three parts zinc white: practice is the only way to learn the correct proportions, but you can remove the gouache by wiping with a moist cloth and trying again. I deliberately cut into the land's skyline with the mix, which produced a result more effective than painting the sky before the land horizon.

12 I used phthalo blue, marigold yellow and zinc white to produce a darker skyline, heralding the approach of changing weather. However, I was not particularly satisfied with this and ran a 7.5cm (3in) decorator's brush across, to lift off the paint and expose the watercolour underneath.

Inset: This matched the brushwork of the land below more closely, and left the sky to be reworked.

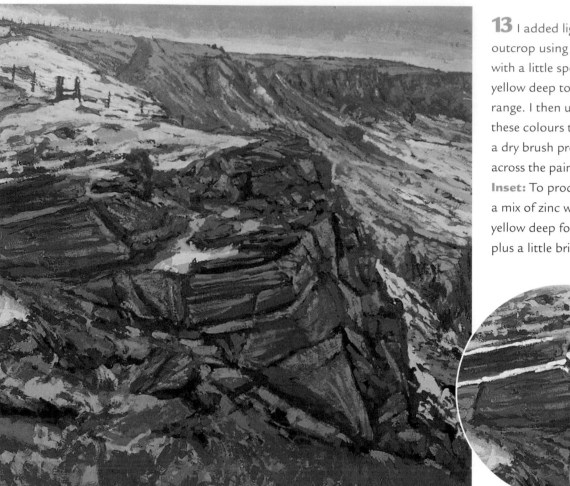

13 I added lighter relief to the rock outcrop using azure blue and zinc white, with a little spectrum red and permanent yellow deep to give an 'in shadow' tonal range. I then used varying proportions of these colours to show the rock surface – a dry brush produced an effective relief across the painting in a couple of minutes.
Inset: To produce good contrast, I used a mix of zinc white and a little permanent yellow deep for the sunlight on the rocks, plus a little brilliant green for the grasses.

14 I added further highlighting in the foreground to lead into the picture and the moorland middle and distance. I then lightened the path in the bottom foreground with zinc white and a little flame red, and darkened the crevices in the rocks with cobalt blue and Vandyke brown to increase the depth of contrast.

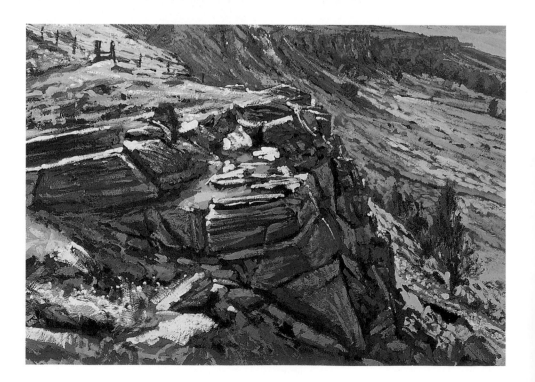

15 Using the flat of a palette knife, I drew a mix of zinc white, a little permanent yellow deep and lemon yellow plus Aquapasto left to right across the painting, to catch any high points on the gouache. In a sense this is a random process – but sunlight would touch across those points, so the effect was accurate. A few touches on the distant areas added light to the composition, and I used the knife edge to create the coarse grasses in the foreground.

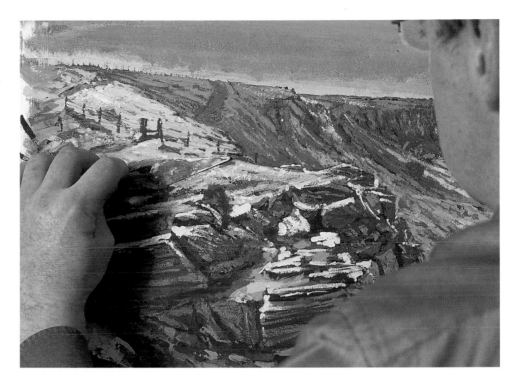

16 At this stage I felt that the areas of watercolour showing through were a little dominant, so I partly overpainted them. I finished the paths with zinc white and a little flame red and marigold yellow, keeping the middle top moorland all in shadow and adding contrast with secondary, lighter shadow areas. Next, I added light back into the sky using short brushstrokes of zinc white with azure blue. I formed the clouds by drawing zinc white and a very little permanent yellow and flame red across with the edge of the decorator's brush; the paint mixed on the painting. Finally, on the horizon I placed some brushstrokes to represent walkers so that the viewer could more readily see the size of the gritstone edge (see pages 62–63).

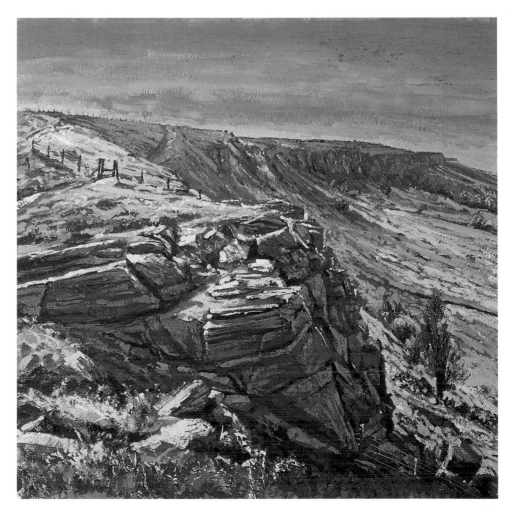

The Finished Painting

Stanage Edge
61 x 61cm (24 x 24in)

In this landscape I aimed to convey something of the grand, untamed nature of the moorland edge, using broad flat strokes of colour that appear and disappear across the painting as a woven tapestry. The best effects often come through chance or taking a risk, and in this painting I have tried to show how you can weave the colours, chopping and changing with gouache in a manner that watercolour alone would be unable to achieve.

This particular project also demonstrates the extensive use of gouache in its own right, with watercolour being used primarily at the underpainting or preliminary stage. Consequently, it has achieved results that you may have previously wished to get from watercolour – the ability to overlay colours in a less restrained way, to build up relief or texture into your painting and, above all, the ability to change your mind without regretting it.

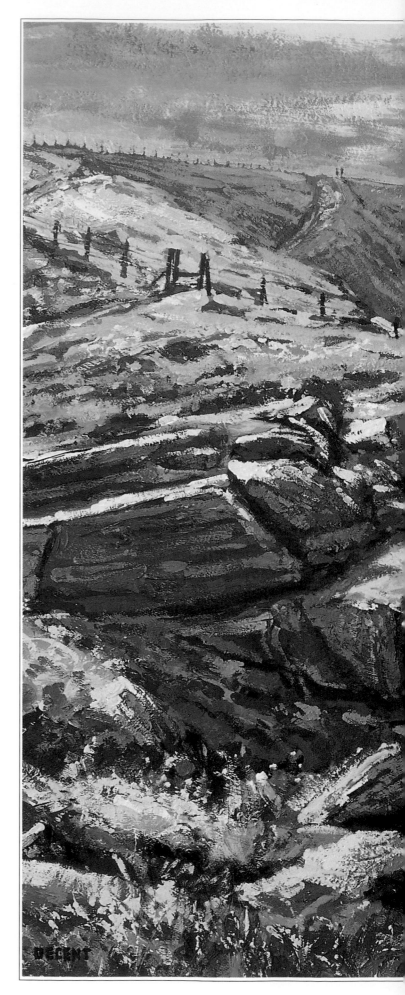

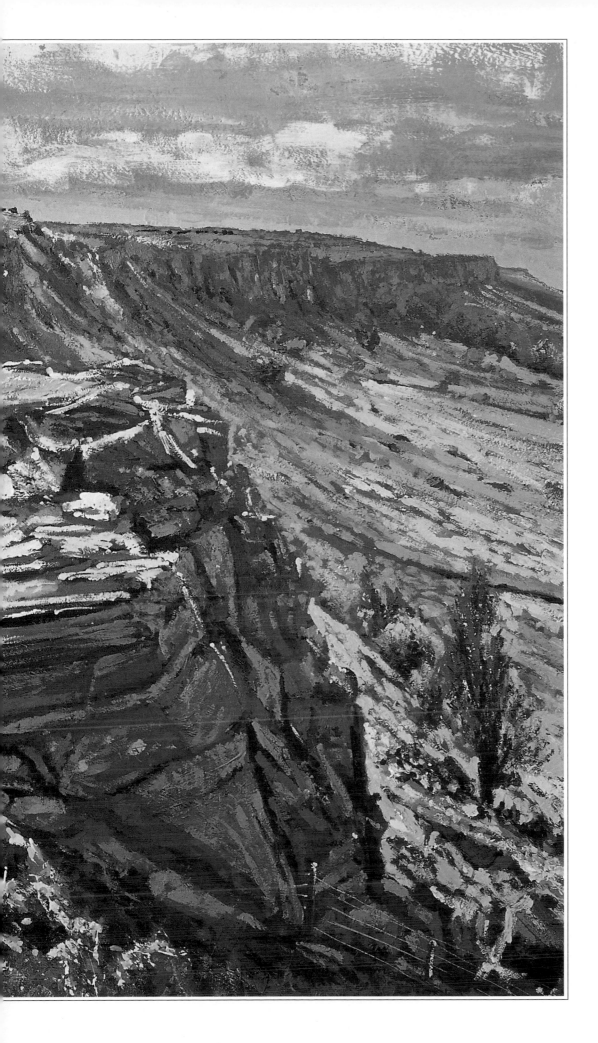

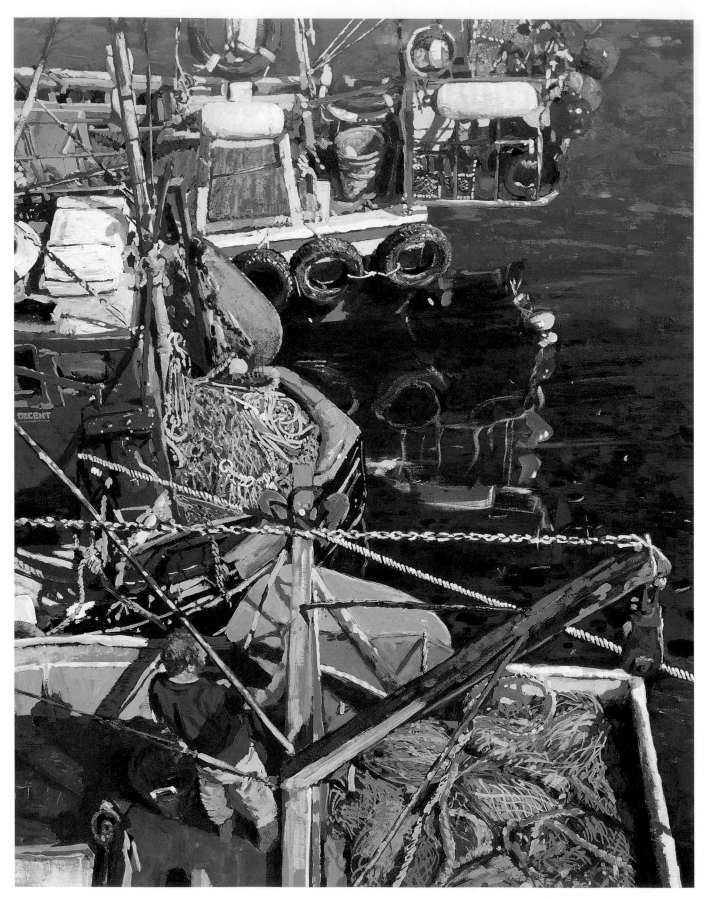

Opposite: **Between Tides, Oban Harbour**

53 x 40.5cm (21 x 16in)

This was a challenge to myself — to make order and composition out of the chaos and complexity of moored working boats.

Right: **Clear Blue Day, Carl Wark from Burbage**

30.5 x 40.5cm (12 x 16in)

This scene is half an hour's walk from Stanage Edge (see page 55), and shows an Iron Age hill fort on the winter horizon.

Below: **Autumn, Ivy Cottage Lane**
28 x 46cm (11 x 18in)

Colour is the subject here — I am always keen to take an everyday location and try to make an interesting painting from it.

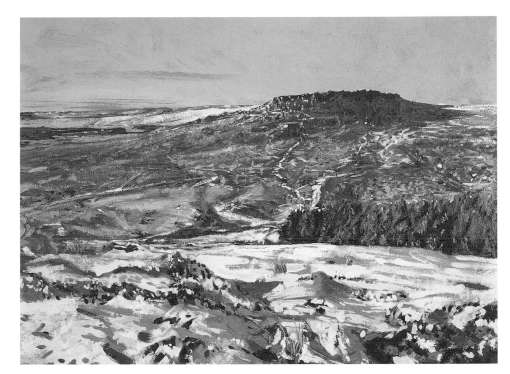

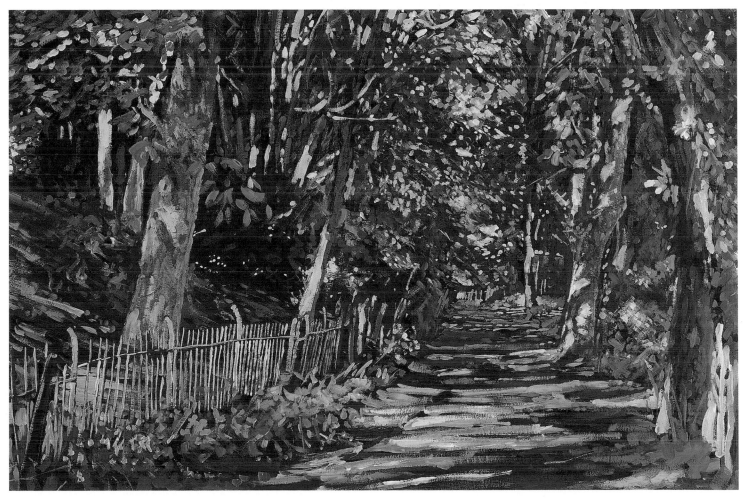

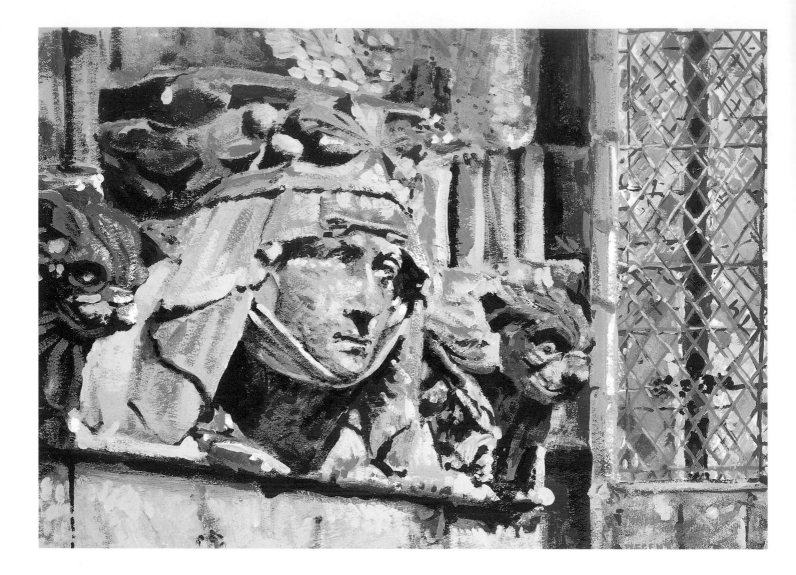

Above: **The Erosion of Memories**
15 x 20cm (6 x 8in)
*This carving is on the outside of Tideswell
Church, Derbyshire, and I was interested by
the perception of the subject. If you paint
the stone accurately, as eroded by the
weather, is the painting more or less
accurate? Second, which is the 'real'
image — the painting or the carving?*

Opposite: **The First Stone**
48.5 x 40.5cm (19 x 16in)
*Another painting about stone and its
erosion over time. The composition is
random and without judgement, but the
aim of the painting is to show the beauty of
nature. The title is a reference to Jesus, who
is represented by the crucifix.*

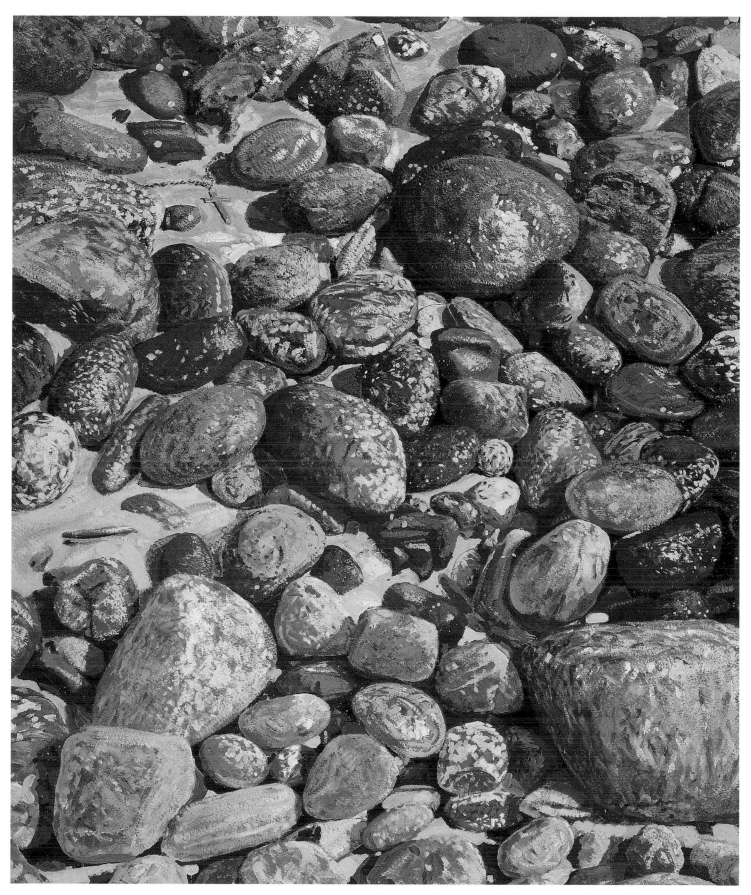

Watercolour *plus...*
Pen and Ink

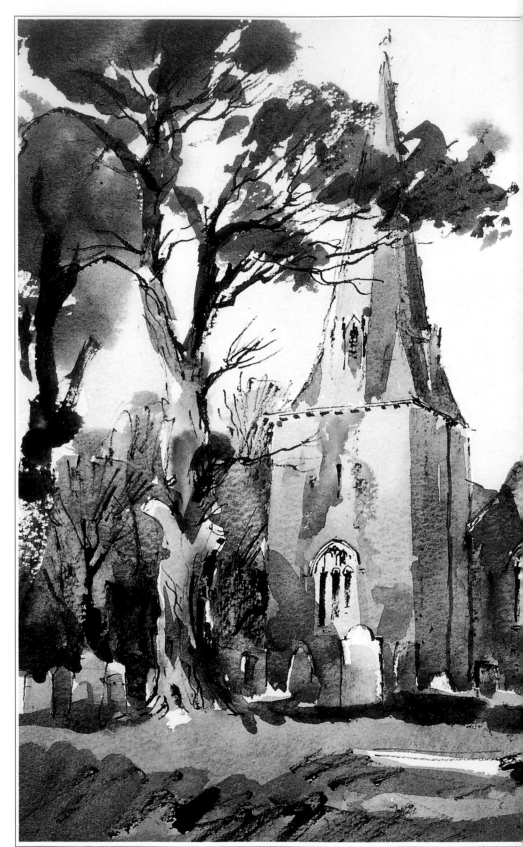

Pen and ink with watercolour (or wash) added is one of the oldest methods of representation in art, and remains popular because it is a quick and simple method by which detail can be suggested in a few lines in an otherwise free-ranging picture.

Using waterproof (Indian) ink allows you to suggest the general lines of the painting, as well as areas of shade and very deep accents which form the 'bones' of the finished picture. I use a 'pen' that is in fact a sharpened twig or matchstick stuck into a pen-holder or piece of bamboo. This produces a less uniform line than a steel nib, one that more resembles a charcoal effect. The beauty of this combination is that the pen drawing can be overlaid with the simplest and most straightforward of watercolour washes. The resulting painting is therefore likely to be fresher and more transparent than a 'pure' watercolour, in which many washes are laid over one another and which can then turn out 'muddy'. With this method you should try and achieve the correct tone and colour first time if possible, thus achieving the greatest transparency.

JOHN HOAR

King's Nympton, Devon
30.5 x 48.5cm (12 x 19in)
A typical village church surrounded by fine old trees. The delicate tracery of the branches is suggested by pen, while broad watercolour washes overlay the rest.

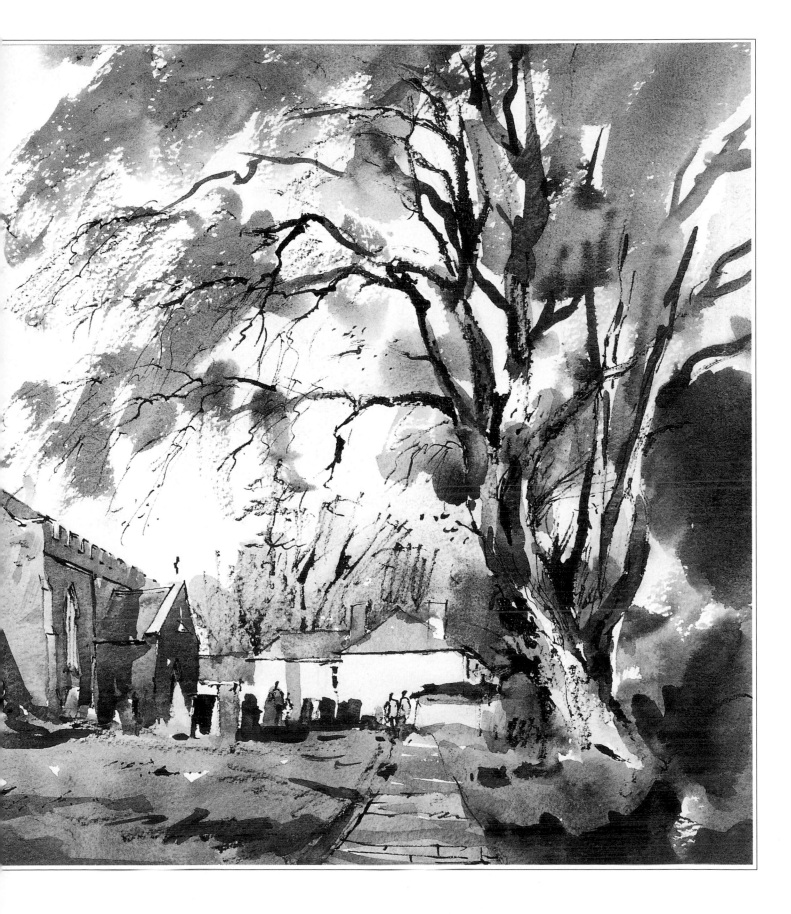

Materials

Ink
I use black waterproof ink (known as Indian ink) as it can be washed over with watercolour without smudging. I find it is the most reliable of all the inks, and it also provides the greatest contrasts in light and shade. My method is to draw the subject in ink first and add watercolours afterwards, but I am well aware that many artists, such as the late John Piper (1903–92), wash their paper over with colour first and then add the ink drawing. Obviously with this method, waterproof ink does not have to be used.

I use both full-strength ink and various strengths of dilution for drawing.

Watercolours
Traditionally pen and wash was generally a monochrome medium, and it is worth trying to restrict your colours, as so much of the work of a pen and ink painting is done before the colour is applied. A well favoured combination would include about five colours, for example raw sienna, Paynes grey, burnt umber, light red and cobalt blue. These can be combined to form a wide variety of colours and textures. In order to keep down the cost, all these colours may be bought in students' quality tubes (tubes being preferable to pans, which can dry out), except for Paynes grey, which must be artists' quality. Other useful colours are the Winsor blue and yellow, though I use these less for pen and ink work.

Paper
I use a thick, smooth Bockingford watercolour paper, generally 410gsm (200lb), although 300gsm (140lb) is ample. I do not stretch my paper, because this takes a long time and it is rather intimidating to be faced with an immaculately stretched surface. You can practise the techniques opposite on any hot- or Not-pressed paper – even smooth cartridge paper can be used as a learning surface.

Pen
The 'pen' I use is generally a matchstick thrust into a short length of bamboo, which I then sharpen to suit with a razor blade or craft knife –

the actual shape is the one that works best in a situation, and can be wedge-shaped or with a more rounded or sharp point. The result will be a bit unpredictable, and some practice will be needed before you get used to it. Alternatively, a sharpened twig taken from a bush might be just as good.

Techniques

The technique of watercolour plus pen and ink can most easily be summed up as a pen drawing with coloured washes splashed over it. The technique (and the work) is mainly in the pen drawing, and the secret is to make the washes as light as possible.

If the subject is complicated it is a good idea to make a not-too-detailed pencil drawing first, because the ink, once it is applied, can't be removed. Then make as free an ink drawing as possible. The pen can be used not only for the outlines of the subject and for intricate details, but also for texture and shadows. In fact it is these last aspects of pen and ink that make it such a useful medium.

When you come to the watercolour stage it is important to let the white paper shine through, so I try to make as few washes as I can. A simple rule might be: use one wash for the basic colours, another for the tone, and one more for the shadows. In some places there will therefore be as many as three washes (one on top of the other), while there might be other areas of pure white (the paper).

Simple lines

I sharpen my matchstick into a wedge shape so that I can produce many different thicknesses of line for different sorts of requirement. If the ink doesn't flow very well I cut it again until it works.

Deeper lines

Deeper areas of line can be achieved by adding more strokes. Always try to work quickly, and try not to get bogged down in the detail of your work.

Hatching

Quick up-and-down strokes are useful to indicate areas of shade and cast shadow if you are unable to finish the painting while on location.

Texture

On buildings or foliage, texture can also be indicated with the pen, thus obviating the need to get down to detail with a brush. In a pen drawing the pen does most of the work, leaving only light washes of colour necessary.

Weight

The harder the pen is pressed the darker the line, and vice versa. Here, a wintry tree form is expressed with the minimum amount of trouble.

Darks and lights

Pen and ink is most effective when used to indicate the extremes of dark and light. Here is a window deep in shadow on a sunny day.

Wash

This shows a preliminary ochre wash over the whole subject. This can be varied from area to area in tone and colour, to take account of any different requirements.

Wash with added tone

Here, the addition of tone – not indicating shadow – is achieved by adding a different colour or depth of colour to the preliminary wash.

Shadow

Shadow is indicated by adding blue to the initial ochre wash. Cast shadows are generally darker still.

PROJECT:
Venetian Townscape

Venice must be one of the most popular of all destinations for artists: not only are there beautiful and crumbling buildings, but there is also the unique quality that is given to the place by the ubiquitous water, sometimes bright, sometimes dark, moving or still. And the reflections in the water of boats, buildings and sky are a never-ending source of delight.

As in many old cities, it is quite difficult in Venice to find a location that is not confined by tall buildings. With the exception of the Grand Canal and St Mark's Square, there are only a few open spaces that give a good opportunity to the sketcher. However, the piazza of the Scuola San Marco is one such place, and it is also distinguished not only by the magnificent buildings and the statues, but by the bordering canal

and its fine arching bridge, too.

The whole scene makes a very satisfactory composition. On the right the façade of the school makes a strong vertical statement which is balanced by the long stretch of canal leading the eye into the distance. This is punctuated first by the bridge and then, further on, by the natural shapes of the tree (a feature that is always a very useful adjunct to any drawing of architecture).

Tones are also important, and the rather cool whites of the marble here contrast with the warm ochres of the plaster and also with the pink brick of the bridge. The whole picture is given life by the water, reflecting buildings, boats and above all, sky. The figures provide scale and movement.

I decided that the sunlight should come from the left. This gave me a

strong, dark L-shape of buildings on the left-hand side, which showed up the bright façade behind them while throwing the well lit bridge into sharp relief. The sky and water are of the same blue as the shadows on the buildings, and the whole painting was completed with only five colours.

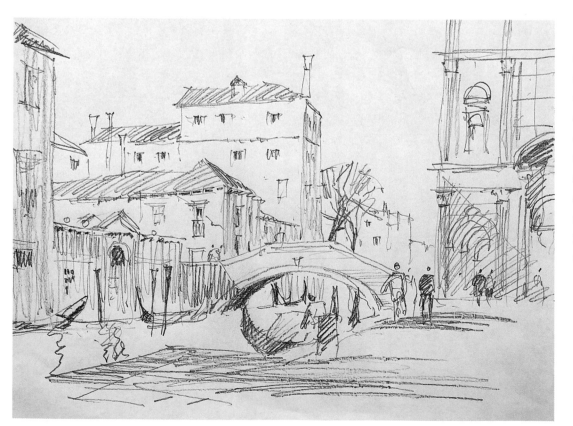

Left: *This is a preliminary drawing for the purpose of making sure that the composition works. I roughly indicated with hatching the areas of shade and cast shadow, the position of boats and figures and so on. I always use a very soft pencil, as it makes quite clear where the lines are without messing up the paper.*

Materials

- 38 x 56cm (15 x 22in) sheet of 410gsm (200lb) Bockingford HP watercolour paper
- 6B pencil
- Black waterproof (Indian) ink
- Sharpened matchstick in bamboo holder
- Watercolours:

 - raw sienna
 - light red
 - cobalt blue
 - burnt umber
 - Winsor blue

- Brush:
 No. 16 round

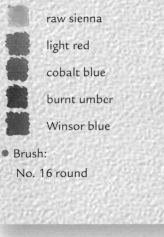

1 Normally I would draw in the whole composition on the spot in pencil and then start inking it in. Here, I transferred the initial drawing in my studio to the watercolour paper. Working very quickly and not getting worried about detail too much, I started the drawing.

Inset: Working from left to right so as not to smudge the ink, I put in the general outlines, adding, where necessary, indications of texture such as the roofs.

2 The bridge was the focal point of the picture, and the underside was so dark that I could draw it as pure black. Above the bridge I added the wiggly lines of the tree so as to introduce a natural and undisciplined element into the formality of the buildings.

3 At this stage it all looked very sketchy – and it was! What I was trying to do was to suggest architectural detail without getting too fussed about it. I was making a painting, not a photograph.

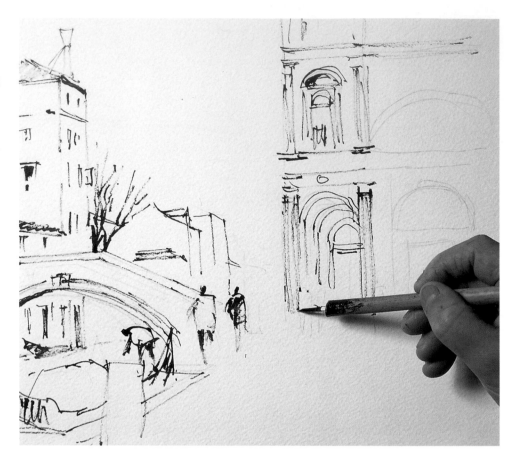

4 With the paper beginning to fill up, I then put in a few figures. These were not absolutely necessary to the composition, but they provided scale and added interest.

Inset: Note the size of the marble bollard in the foreground next to the one behind.

5 Here, I hatched in the area of cast shadow on the left-hand side of the bridge, to remind me how dark these shadows were. Shadows cast on buildings which otherwise would be sunlit are darker than those on the shade side of a building. The contrast between the two can be extremely effective, and I used it to point up the different positions of the various façades.

Inset: I next turned my attention to the general shaded area of the buildings on the left, which I indicated by light and rapid hatching.

6 I was now beginning to think about specific areas of deep shadow, as in the tympanums of the arches, which were very dark.

Inset: Looking at the picture overall, I paid more attention to some areas than others – as a general rule, if the eye is satisfied that the detail is there in the foreground, then it will assume that it is in the background as well, even though this has received minimal attention.

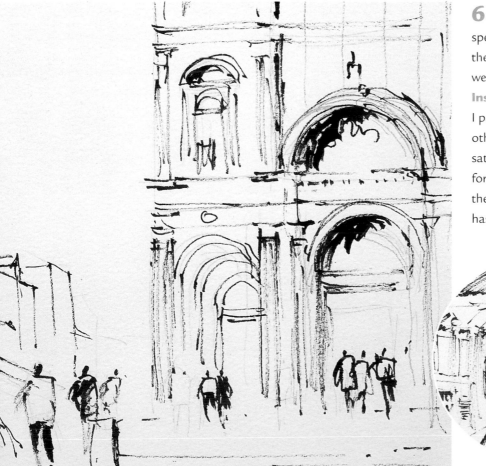

PROGRESS REPORT

At this stage, the inking-in was finished and the main tonal features of the final painting were now in place. The whole thing was done in very quick time, because it was important not to allow the ink drawing to take over the painting. Nevertheless, doing it in this way enabled me to balance the drawing in terms of composition, and also to set the tonal areas. The dark shadows of the doorway on the right answered the long shaded buildings on the left, and the L-shaped composition was restful to the eye.

I indicated a certain amount of texture on the walls and roofs, to help me to vary the tones of the subsequent watercolour washes

There is just enough incidental detail in the way of boats and people to prevent the drawing looking like a stage set

I left out the water of the canal, which I intended to deal with very near the end, as it could be the making or breaking of the painting. Water is in the same special category as sky – an element of its own which follows different rules from everything else

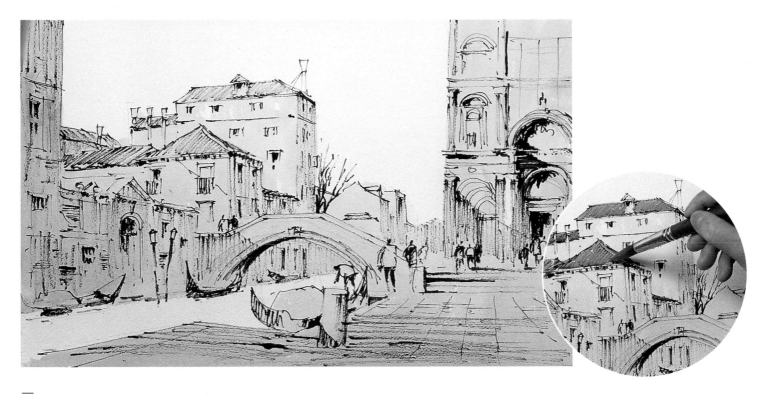

7 I began the watercolour stage with an overall wash of a weak mixture of raw sienna and light red, applied with a No. 16 round brush – which I used for all the washes in this painting. This formed the basic underlying colour and tone of the buildings. I purposely left out areas of the sky and canal: because the sky and water are complementary, they could be left until towards the end of the project, by which time I would be able to assess how they could contribute to the finished painting.

Inset: I next put in the local tones of the painting, applying the same raw sienna and light red mixture to all the roofs with the intention that the picture would be easy to 'read'.

8 As I added more local colour and texture, I was careful to leave the white marble borders of the bridge showing brightly against the pink (light red again) of the brickwork. On the left, I laid on the greenish hues (a mix of cobalt blue and raw sienna) quite thickly – because they were nearer to the viewer, it should be possible to make out their colour and depth. On the right, I added tone to the front of the school using washes of raw sienna and burnt umber.

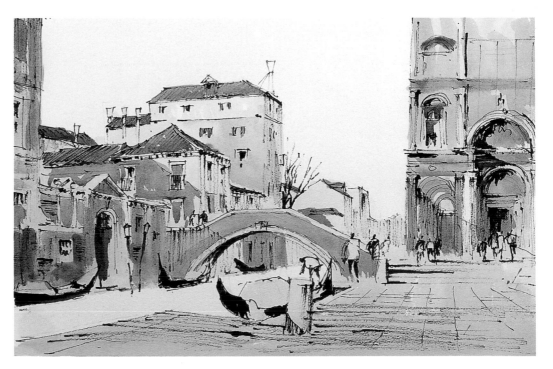

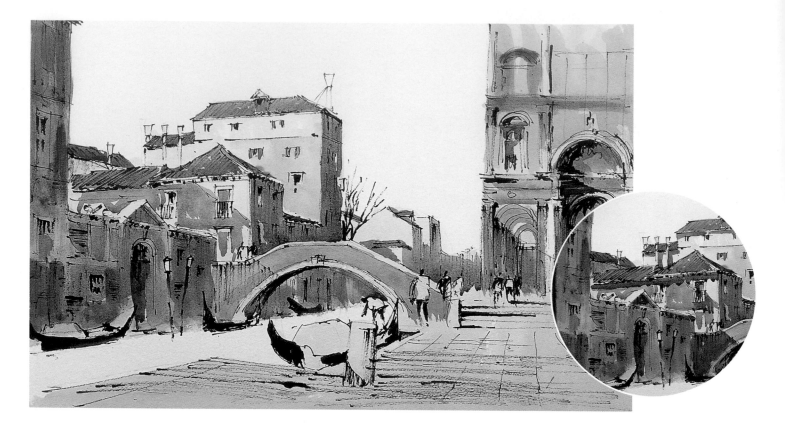

9 Having sorted out most of the different tones, I started on the shade-sided shadows using a strong mixture of cobalt blue with a little raw sienna – in an Italian scene, the shadows were likely to be fairly dark. I was thus very careful to make the shadow above the bridge very clear and sharp. Further into the distance, I added water to the mixture so that the blue faded away.

Inset: I applied the cast shadows under the eaves of the roof and on the left-hand side of the bridge with a darker blend of the shade-side colour mixture. This developed a clear contrast between the shadow on the bridge and the building to its left.

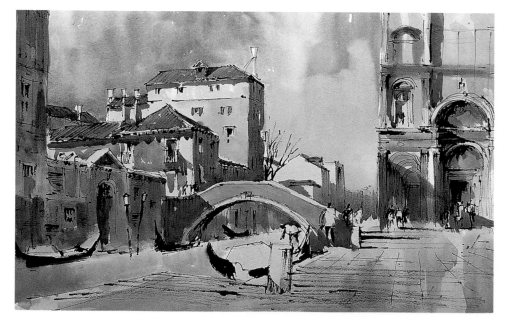

10 Having left them almost to the last, I painted in the sky and the water, using a mixture of cobalt blue with a dash of raw sienna to warm it up a bit. On the right-hand side I added a triangle of cast shadow to the school's façade, thus tying it in with the buildings on the left. I also applied a pale bluish wash to the pavement to lend it more interest.

11 After a lot of thought I decided to darken down the canal with murky reflections on the extreme left and lighten it up towards the bridge. This provided a sharp contrast with the edge of the pavement, which immediately leaped out, having been unclear before. Using a wet-in-wet technique, I dropped in a mixture of Windsor blue and burnt umber where the water abutted under the buildings, and watered the mixture down elsewhere so that it became a greenish reflection of the general colour above. With a very dry No. 16 round brush and a strong mixture of Windsor blue and raw sienna, I very quickly brushed over the tops of the trees in the distance, being careful to leave some holes through which we might see the sky behind.

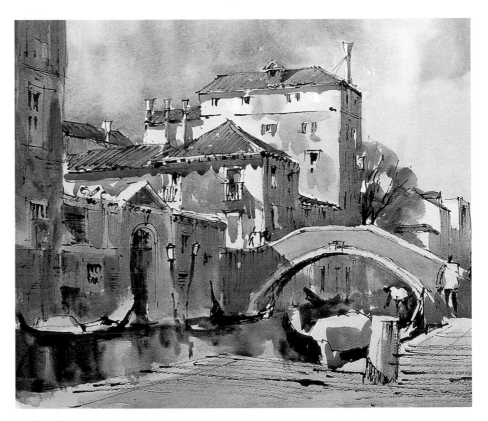

12 Finally I added a cast shadow across the foreground, and also strengthened the cast shadow from the bridge so that the large area of the pavement was broken up. I also added some blue shadow to the top right-hand side to soften the impact of the bright stonework against the corner of the painting. I emphasized the difference between the cool blue of the shaded areas and the warmth of the sunlit plaster and brick.

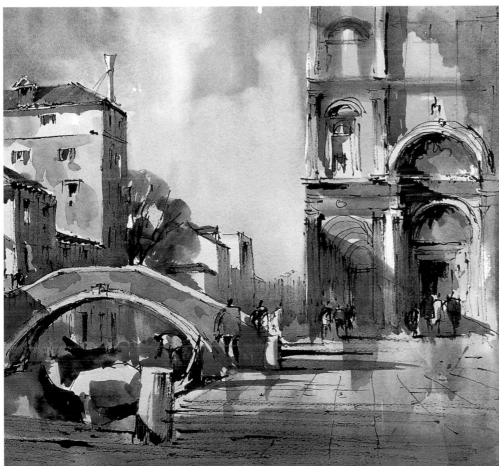

The Finished Painting

Scuola San Marco, Venice
30.5 x 48.5cm (12 x 19in)

I think the combination of pen and ink and watercolour has worked well here. It is a subject that does require a certain amount of detailed definition, which would have been more difficult to capture with, for example, a small brush. There are also a few areas, in doorways and windows, where the depth of solid black ink is particularly helpful and time-saving. Yet the pen and ink does not take over the painting, which has managed to retain its freshness and a balance between the drawing and the subsequent washes.

It is worth keeping in mind that it is always possible to add pen and ink after the watercolour washes have been finished, if you think this is necessary. It is better in the pen and ink stage to do too little work rather than too much.

There is always the problem, faced by all painters, of 'When shall I stop?'. I think I stopped in time in both stages here – which was probably as much to do with luck as with judgement.

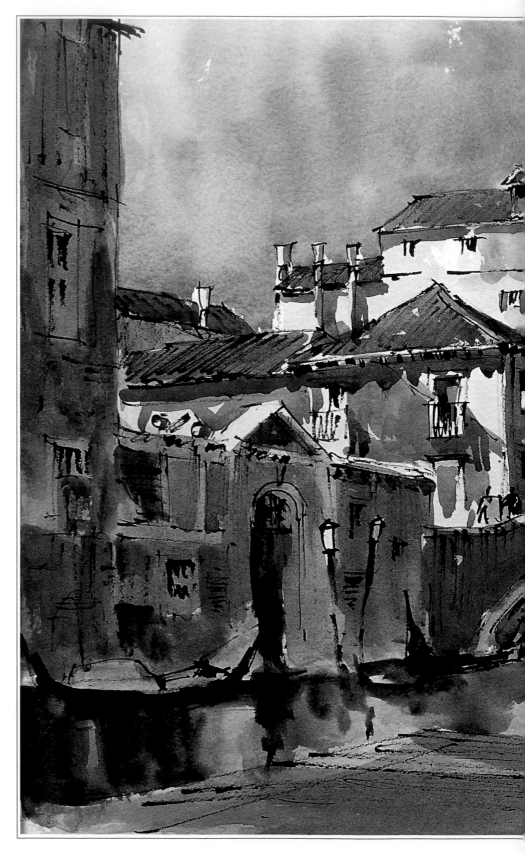

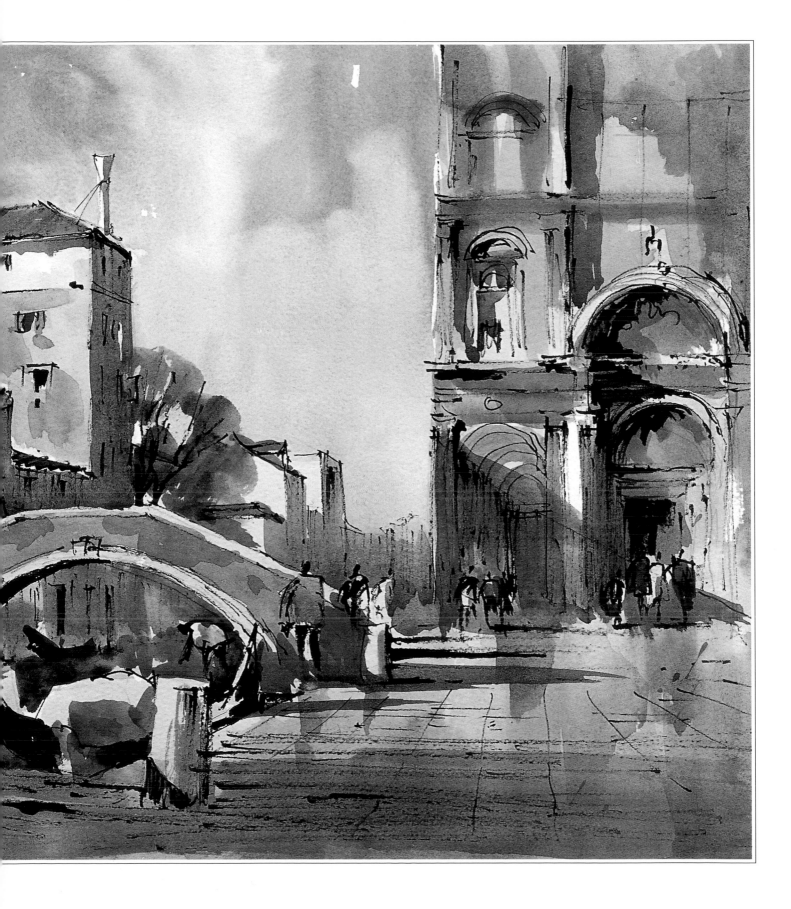

Above: **St John's Point, Co. Donegal**
30.5 x 48.5cm (12 x 19in)
For this picture of a wet summer day in the north-west of Ireland,
I applied the darker clouds with a dry brush while the sky was still
wet. The puddles add a light accent to the shade of the foreground.

Opposite: **Topsham, Devon**
40.5 x 30.5cm (16 x 12in)
In this quiet scene in an old fishing port, the white cottages with
their black bases on the right contrast with the large brick house
in the centre. I used the dark shadow across the front to 'push'
the rest of the buildings back.

Above: **Sidmouth, Devon**
30.5 x 48.5cm (12 x 19in)
I used the hedge on the right of this composition to lead the eye into the picture, and added the figures to give a sense of scale. The dark trees in the background bring the house on the left forwards.

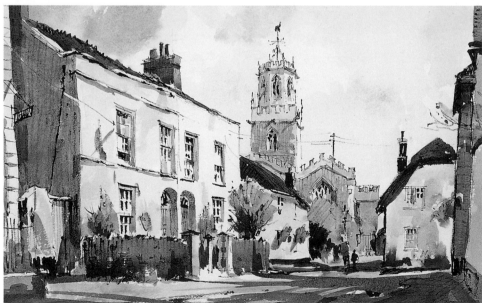

Above: **Colyton, Devon**
30.5 x 48.5cm (12 x 19in)
The buildings of many periods make this composition an interesting one. I used the natural forms of the trees and foliage to soften the man-made environment.

The Cloister, Muchelney Abbey, Somerset
51 x 35.5.cm (20 x14in)
This beautiful medieval interior is just about all that remains of a great building destroyed in the sixteenth century. It is a perfect subject for pen and ink, which can indicate without fuss the complexities of ancient vaulting and masonry and the romantic effect of centuries of decay.

Watercolour *plus...* Oil Pastel

I love mixing other media with watercolours to create adventurous and individual effects. Oil pastels serve this purpose extremely well because they are so versatile: I use them as a resist with watercolours, or apply them alongside or on top of a dried wash, similar to working with traditional soft pastels. Oil pastels can be used to enhance textural qualities, using their 'oiliness' or 'stickiness' as a contrast to the fluidity of the watercolour washes; to highlight or define decoration or details; or to build up massed effects such as foliage. The secret is to contrast the two media – light against dark, softness against deep texturing, busy markings against bland washes, and warm colours against cold ones. This will bring out the beauty of both media, and not end up by muddling or disguising either one.

Most art stores stock many makes, sizes and colours, which can often be obtained separately or in set boxes of up to 80 sticks. Oil pastels are equally successful on location for quick sketching and effects, as they are highly portable, or in the studio for lengthy and more elaborate work.

There are no set rules when you are combining watercolours and oil pastels – anything goes that works well! Setting aside some 'luxury' practice time before starting anything is well worth the effort – confidence only comes with experience, and regular practice will result in successful and unique ways to enhance all your future work.

WENDY JELBERT

Chickens

25.5 x33cm (10 x 13in)

A variety of techniques was used to keep the picture alive and natural-looking. In addition to the contrast between the watercolour washes and pastels, a range of textural markings was essential for the foliage, feathers and the scales on the legs.

Materials

Watercolours

I use mainly artists' quality, but always go for the colour first – in addition, I mix several of my own, sometimes using students' and artists' quality together. I usually squeeze tubes into my paintbox or empty pans – I prefer double pans to single ones because they hold a greater reservoir of colour, making them easier to use.

Papers

I use 300gsm (140lb) Not-surface papers, particularly those made by Bockingford, Saunders Waterford or Daler Rowney's Langton. I fix sheets to a drawing board using masking tape. I do not stretch my paper, because I find that good makes do not need to be stretched – and if all else fails, I use the back of a previous work!

Oil pastels

These come in a wide range of shapes, sizes and makes, but not all brands are compatible with watercolours, as some seem to 'drown' in the wash stage. The pastels need to be 'meaty' and 'fleshy', with a great deal of covering power so they can effectively resist the watercolours.

I break the pastels into 2.5cm (1in) or 3.8cm (1½in) lengths to be able to produce an assortment of marks. To make this process easier, I remove all the labels. When building up a palette of colours, try a few light colours to start with, and add to these later on. Good makes include Reeves, Inscribe and Winsor & Newton.

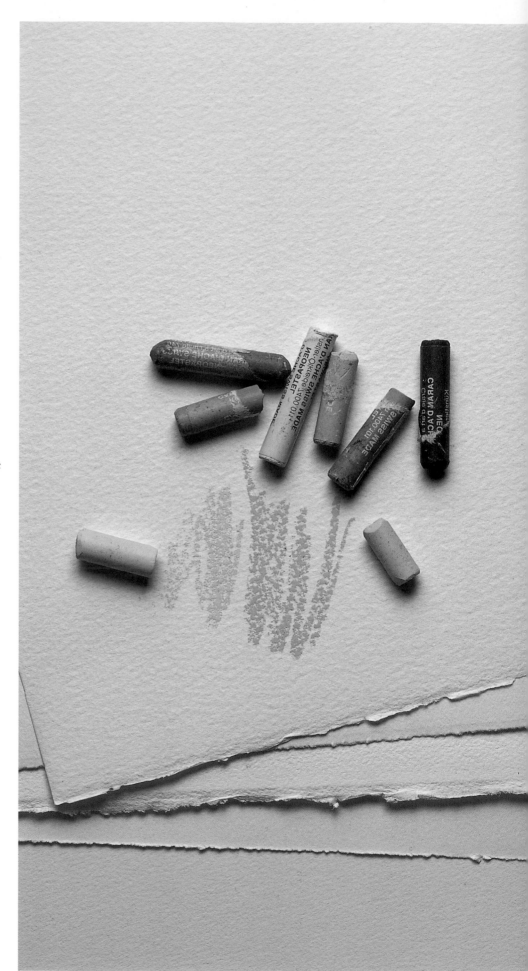

Techniques

This following section demonstrates how watercolours and oil pastels can be married together to create unique effects. These pastels are opaque and 'gluey', and can sometimes obliterate the watercolours, or just diffuse the object slightly, depending on how much pressure is applied to the pastel, and at what stage it is added.

Watercolour on pastel

To draw this bricks and mortar design, some of the white paper was allowed to show through the pastel work. Darker watercolours were then applied so that the design functioned as a resist – the washes repel the paint, so the pastel colour shows through.

Pastel into watercolour wash

Here, dark watercolour was washed onto paper and oil pastel was applied immediately into the wet wash – this was used on its side, leaving some of the wash to show through the pastel work. This technique can be used to suggest a weathered or aged surface on an ancient roof or pathway.

Pastel onto dry watercolour

A watercolour wash was applied and allowed to dry, and a pastel design was then drawn over the top, obliterating the wash beneath. This works particularly well for highlighted and detailed effects, such as flowers, foliage or decoration on surfaces.

Combining techniques

Oil pastel was applied at different times in one picture, using a combination of the three techniques above. The resulting surfaces are useful for more complicated textures such as tree bark, river banks or wooden boats.

Scumbling

Here, a graded watercolour wash was combined with a network of dense and trailing pastel markings, some over one another so they partially covered the one below. Using this technique, exciting results can be created by making use of either complementary colours, or a whole assortment of different markings. Darker pastels can be scumbled over lighter pastels to diffuse the ones below; scumbling is ideal for drawing massed areas of foliage or flowers – whether this is in the foreground or in the background.

Repeating motifs

A design of ovals was repeated in assorted colours and sizes over one another, using oil pastels of different colours – note that pastel is always brighter when applied directly to the paper than at any other stage. A darker wash was then added, and additional circles were worked into the pattern, both when it was still wet and also when it had completely dried. This is very useful for paintings that portray paving, walls or other stonework.

Crosshatching

This image was fused by crosshatching over the top of the original finer detail. The original image can be drawn for decoration on pots, still-life objects or roofing, for example, and then diffused by smaller lines that soften that image. This provides a feeling of structure or shading to the surface.

PROJECT:
Outdoor still life

I find the entrancing play of sunlight on objects, and the network of deep shadows and swaths of dappled shade it creates, really fascinating – the combination thrills me every time I start a picture containing it. For this project I chose a gorgeous corner that encapsulates everything, including the textural qualities I wanted to use. I worked from a snapshot and sketch made at Eze in Provence, France, on a holiday in 2001 with my husband, who paints as well.

This view contains a perfect focal point, with the staircase and growth of the wisteria leading the eye naturally up from the left and down to the right towards the doorway. In addition, the strong shadows and sunshine are in sharp relief, highlighting and compounding dramatically the whole scene. The portrait format accentuates the graceful light of the stone stairs and completes the flowered corner.

I often use two sources of artwork – sketches and photographs – and I like to do several quick try-outs as thumbnail sketches before I start, just to convince myself I have done as much preparation and problem-solving as possible before starting.

Right: *This was one of many photographs I took in Provence with a view to using the scene in a painting. The climbing wisteria is a strong focal point, and I considered combining it with a different setting.*

Above: *I chose this view of a courtyard in Provence for the dramatic effects of light and movement, its textural qualities and the tonal contrasts within it.*

Artist's Tips

- If masking fluid is too thick to use comfortably, I add 15 per cent water to the bottle and shake it until it resembles milk. If there is no colour to the fluid, I add a little watercolour – perhaps blue or yellow – so I can see where I have put it.

- To achieve sharper details, sometimes the pastels need to be pointed at one end. I glue a small square of medium sandpaper into my pastel box and use this as a sharpener.

Materials

- 40.5 x 28cm (16 x 11in) sheet of 300gsm (140lb) Not watercolour paper
- Watercolour pencil: burnt sienna
- Masking fluid
- Ruling/drawing pen
- Watercolours:

 yellow ochre

 burnt sienna

 neutral grey

 cobalt blue

 violet

 magenta

 olive green

- Brush: wedge-shaped synthetic No. 14 with rigger point
- Oil pastels:

 raw umber

 light orange

 dusky pink

 lilac

 apricot pink

 light green

 olive green

 pale grey

 cream

 bright yellow

 dark brown

- Sheet of medium-grade sandpaper

1 I lightly sketched in the main features using a burnt sienna watersoluble pencil. These marks were mainly for guide-lines, and helped to map out the plan for the whole picture. Next, using masking fluid with an applicator (in this instance a ruling/drawing pen), I carefully applied the highlight areas of the wisteria in small dots – this took some time. I also added a tangle of branches to carry the eye around the interesting foliage area.

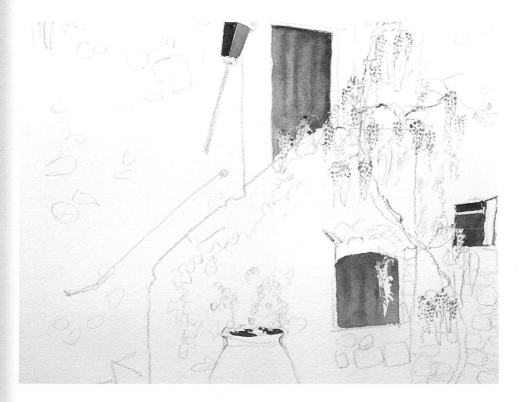

2 Because I like to place in some of the blocks of detail that carry the same colours and tones, such as these doors and the small windows, I left blank the heads of the climbing wisteria plant that clipped the window and door shapes when I started blocking in with washes of burnt sienna. I added some cobalt blue into the wet-into-wet shaded surfaces to create shading.

3 I used lilac, dusky pink and apricot oil pastels to prime the flower heads in colourful highlights, making small, dotted stabbing marks. I took care during this process not to work over the masking fluid and rub it off accidentally.

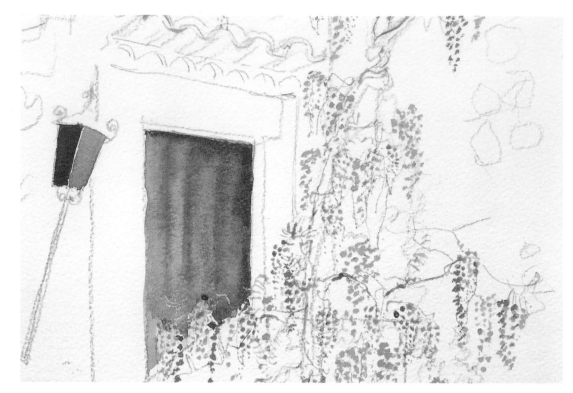

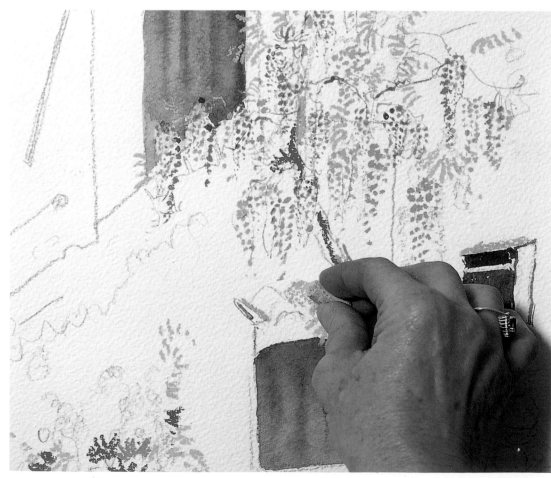

4 The intricate foliage needed to be developed using more oil pastels in pale shades. I painted in some of the flower heads wet-in-wet, without adding all the details – including everything can be just too much and leaves nothing to the imagination – and making a good contrast with the oil pastel detailing on the adjacent ones. I placed in the twisting main wisteria trunk work with dark brown oil pastel, and then started on the large pot with some foliage tufts.

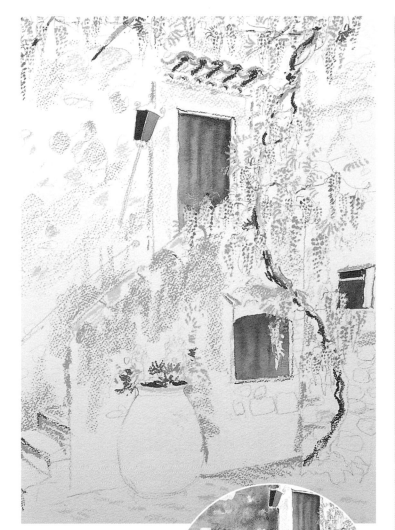

5 To create a weathered, textured effect, I skated over the surface with apricot, pale grey and cream oil pastels, leaving the texture loose and open-weaved so the wall and steps were well primed to resist any subsequent watercolour washes. I placed in more of the character of the twisting vine using dark brown oil pastel, and also added detail to the arch with the same pastel.

Inset: I wetted the overall wax-resist surface with a dark watercolour wash of neutral grey, before adding a few more pastel dots to the flower heads.

6 I drew back into the neutral grey wash while it was still wet, for the stones around the base of the pot. I added some more colours to this wash using burnt sienna and cobalt blue, to provide more shaded areas, to give form to the courtyard, and to bring out the edge of the staircase wall.

Inset: Using washes of violet, cobalt blue and magenta, I started the flowers, making sure that there was a variety of colours and tones within this initial wash.

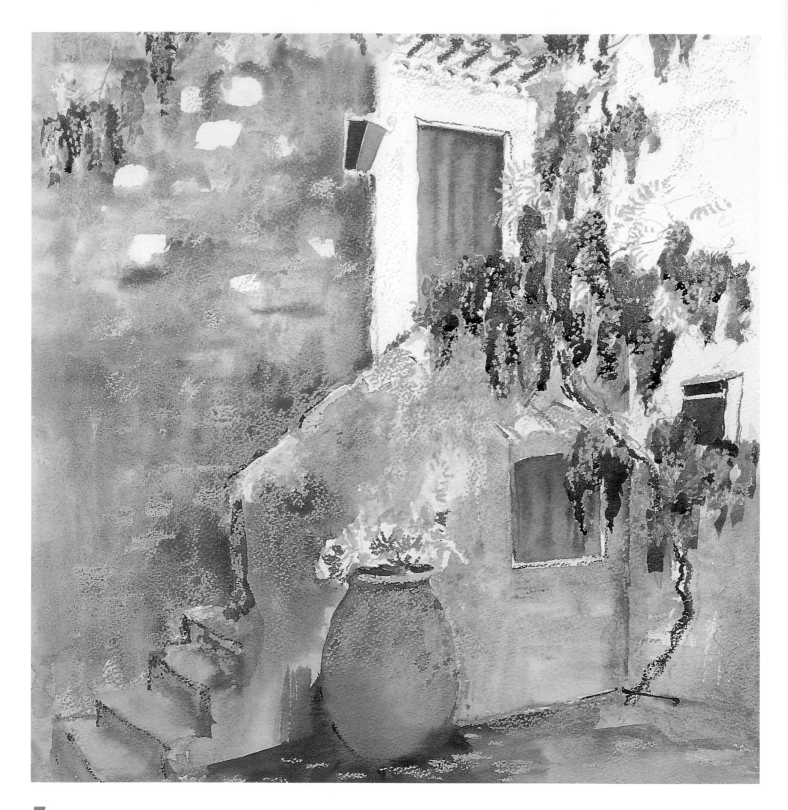

7 I always try and keep a rhythm going when there is a trail of the same plant throughout the same painting, as this keeps the eye 'flowing' naturally within the painting. I started to work on the pot by placing a shaft of pale orange oil pastel over the shape, plus dots of bright yellow for the flowers in it. I then roughly placed some of these apricot colours back into the wall to give a bit of continuity and to bond the colour elsewhere into the picture.

8 I placed on a wash of burnt sienna over the pot, plus some olive green and yellow ochre watercolour to add an ageing effect. Next I applied a wet-in-wet splash of cobalt blue around the pot's base to add more shade on the cobble-stones. I then worked a little more on the flowers with olive green watercolour washes of varying tones, to highlight the yellow oil pastel flowers.

9 I added more colour to the wall with a deeper tone of neutral grey, and then applied a yellow ochre wash over the far stone wall to contrast it with the stairs. I put in washes of cobalt blue, burnt sienna and violet to the staircase so the texture jumped through even more, and added depth and modelling to this area. I then drew in a little more light pastel over the door on the tiling and rafters.

PROGRESS REPORT

At this stage I felt that I had built the picture up successfully, but that it was still lacking the drama and tonal contrasts that would be needed to bring it to an eventual conclusion. My particular areas of concern were that the darker washes had faded too much and thus needed attention; and the focal point at the top of the staircase was now in competition with the flowered pot below, thus detracting from the main area of interest. In addition, the emphasis on the light source needed to be much stronger – I sometimes place an arrow on the side of my painting to remind me of the angle of light.

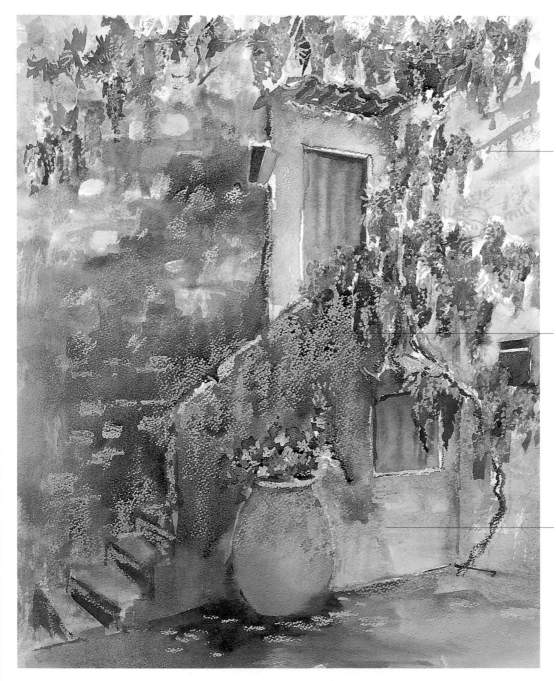

Cream oil pastel over watercolour wash intensifies the light, sunny areas

Tonal contrasts are made near the lightest areas by deeper colours – violet, burnt sienna and cobalt blue

Soft crosshatching slightly diffuses the forms underneath and fades the brightness of the details

10 I started to darken the shadows with a thicker wash of burnt sienna, cobalt blue and violet, spattering these darker tones into the shadows to age the surfaces. I rubbed off the masking fluid with the side of my thumb, exposing the white paper and giving me a second chance to save my lightest areas – this certainly showed up the care with which I had applied the masking fluid. **Inset:** I used a cream pastel to block in the lighter areas on the right-hand sun-filled side of the top of the stairs, and then brought a little of this light over the top of the stairs to define the edges more.

11 I added paler washes of magenta and cobalt blue over the flower heads, then light green to the feathered foliage details. I defined bunches of colours to add visual flow, making sure that the flowers and foliage were not too complicated and muddled. I detailed some of the foliage using olive green, and added violet and burnt sienna to the trunk of the vine in a 'lost and found' way, to make it look more natural. I crosshatched over some of the foliage around the arch to simplify this area, and then completed the pot by scumbling over with a light touch of olive green oil pastel and cobalt blue watercolour wash. To complete the picture, I added a little more reflected light onto the stonework using apricot pink oil pastel.

The Finished Painting

Provence Courtyard
40.5 x 28cm (16 x 11in)

I feel I have brought the painting back on track, and have successfully caught the tonal effects of the sunshine and shadows. Texturally it could be accused of being a little fussy – but this is the element that initially attracted me to the view, so perhaps I *have* gone a little overboard! I like to use masking fluid for details of light and delicate floral features; the extra work involved in this painting was well worth the effort.

The use of oil pastels and watercolour certainly helped to achieve the effects I required, particularly using an open-weave technique for the walls and steps, and the lighter, more defined tracery of the foliage and flowers. You could achieve the same effects using gouache (see page 48), but oil pastel applications are easier. Carrying oil pastels in my paintbox, I do similar work *in situ* working with students and on holidays, and their portability and ease of use makes them an excellent combination with watercolour for capturing sunlight and a great variety of textures.

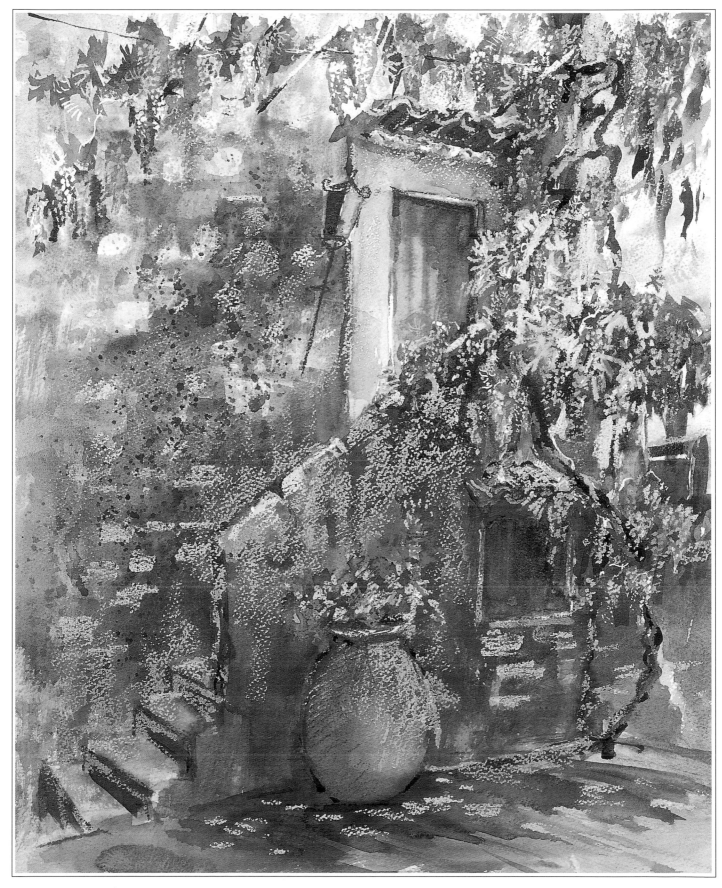

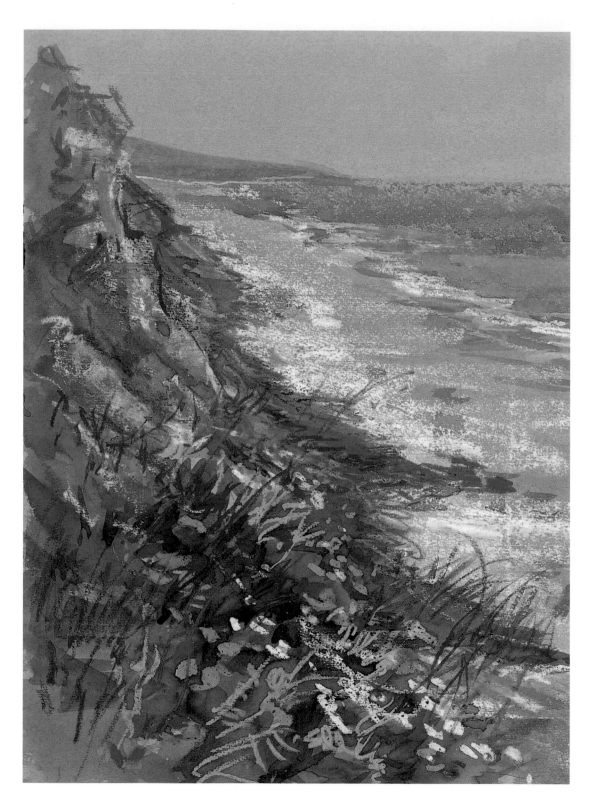

Left: **Dorset Coastal Scene**
36.5 x 25cm (14½ x 9¾in)
The coloured paper provides a brilliant contrast to the assorted pastels used here. I needed to make soft, gentle markings for the distant areas, but also required a strong set of motifs to depict the grasses, foliage, roses and flowers in the foreground.

Opposite: **Deep Reflections**
39 x 30cm (15½ x 12in)
These reflections needed to be free-flowing, and to contrast with the shaded and sunlit backgrounds. I used spontaneous zigzag markings in oil pastels to depict the tree reflections, before applying watercolour washes. When these were dry I drew light markings horizontally over the surface to reflect the sun. The water around the boat needed to be dark as a contrast to the focal point.

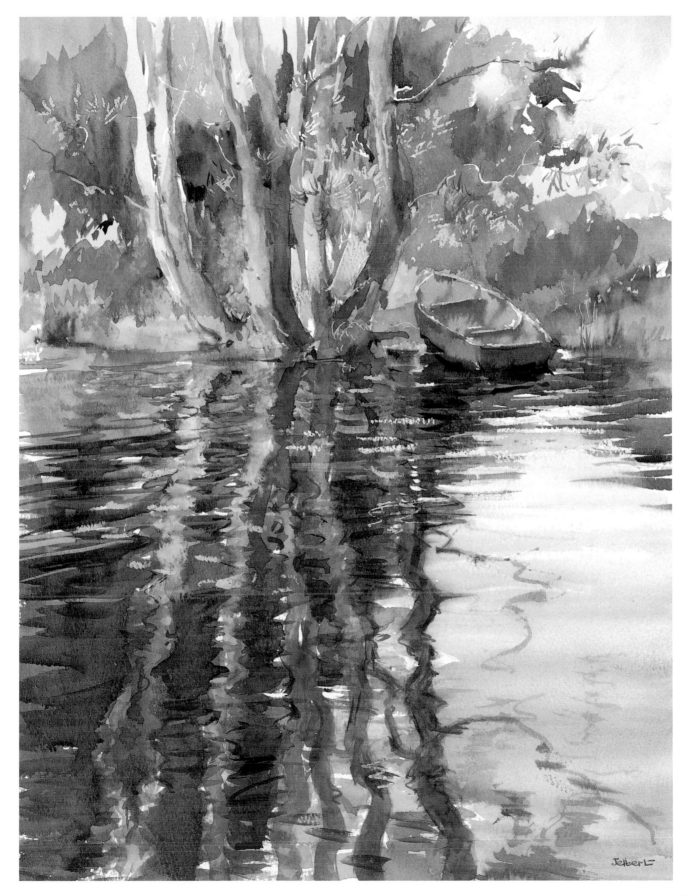

Left: **Still Life**
36 x 33cm (14 x 13in)
I placed these colourful gourds on an offcut of curtain material, resulting in a blaze of patterns and contrasting hues. When working on these complicated subjects I draw a number of thumbnail sketches first, so as to avoid any potential problems before they crop up in the actual painting. I used a mixture of techniques, applying oil pastel under and during the watercolour washes, and on top of the fully dried surfaces. I used scumbling on the fruits, and just enjoyed doodling with the oil pastels to link the patterning to the composition.

Opposite: **French Window**
38.5 x 30cm (15 x 12in)
To produce a weathered effect, I applied watercolour washes over cream oil pastels used on their sides. The net curtains were created using a combination of masking fluid and white oil pastel well sharpened to a point, all covered by a darker wash. To highlight the sunny areas I lightly drew the cream oil pastel across the walls and the shutters.

Watercolour
plus . . .
Collage

Combined with watercolour, collage can enhance a painting in many ways. In its simplest form it can add depth to a painting, giving greater three-dimensional effects and texture. In addition to this I have made extensive use of collage, working from imagination to develop the idea behind a painting by the use of text – poetry or prose – woven into the fabric of a painting; this adds moods and atmospheres that would otherwise be difficult to capture.

As with many forms of mixed media, it is best to start a painting with the idea that collage will be an integral part of the process. As a compositional aid, collage is invaluable: by reducing the work to basic shapes – squares, circles and so on – and cutting these shapes out of different coloured paper, you can then move them around the surface, helping to balance the design.

By combining watercolour and collage in these ways I feel I am also combining traditional painting with a contemporary aspect. I love to experiment and break new ground, and I hope the following pages will encourage you to do the same.

LIZ SEWARD RELFE

Glass on Glass with Lemons
33 x 46cm (13 x 18in)
This was compiled out of several discarded paintings of the subject, some textured with tissue paper, and some plain. The background area, with the 'echoes' of the shapes, was painted last.

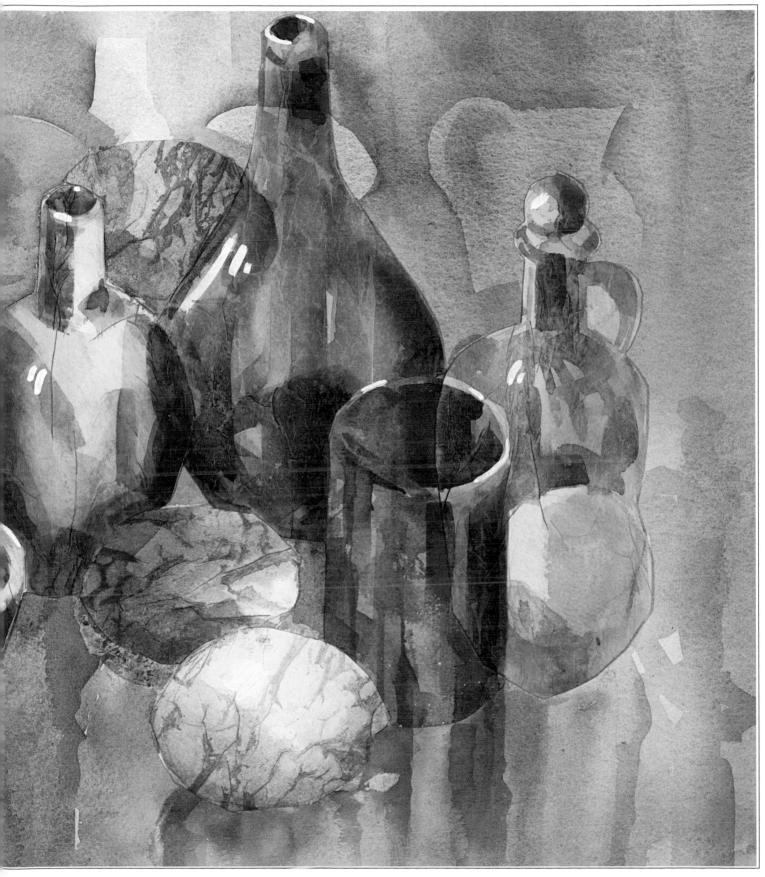

Materials

Watercolours and acrylics

I use artists' quality paints when starting a painting with the intention of progressing as far as I can in pure watercolour, but I keep an open mind about using other water-based paints such as acrylics and acrylic inks, as the surfaces of some of the papers used can be unpredictable.

Papers

As a base, watercolour paper is easily the best, stretched onto a board with gummed tape. I use 180gsm (90lb) Bockingford Not or Saunders Waterford hot-pressed where the majority of the surface is to be covered in tissue or handmade paper, because a heavily textured watercolour paper would appear through these and detract from the textures formed by the thinner top layer.

I use the thinner weight for economic reasons because the two layers of paper will have the strength of a thicker sheet of paper, but the watercolour paper underneath must be stretched on a board either with brown gummed paper or with staples.

Where the greater area of the painting is traditional watercolour, I use Saunders Waterford 300gsm (140lb) Rough, Arches 300gsm (140lb) Rough, or Whatman 300gsm (140lb) Rough, which are the papers I generally paint on. Handmade papers from the Far East, when used as a base for collage, are usually quite flimsy and fragile when wetted, so they need to be mounted on a firm base such as stretched watercolour paper, mountboard or MDF (medium-density fibreboard) coated with acrylic primer.

Glue and adhesives

I use a PVA (polyvinyl acetate) glue for all the collage work that I do because it is so versatile. I buy it in a large container from my local art store, but it is readily available in most DIY and hardware stores and in all good stationers – even your local toy store may stock it for children to use for all forms of art and craft.

For heavier weights of paper that need to be stuck the glue can be used at full strength, but for sticking large areas of lightweight paper, such as some of the handmade papers and tissue paper, it is better to dilute it to the consistency of single cream or even milk. Although it is opaque in appearance when in the container, it dries to a waterproof, translucent film in use and is relatively permanent, unlike other paper glues. PVA glue has little or no smell, and is kind to hands and clothes if it is washed

off immediately after use. When it is used with watercolour it acts as a form of size or sealant, and therefore makes any paper it is laid on less absorbent; so you should take care not to lay it on papers where watercolour techniques such as wet-in-wet are to be used.

Other collage materials

Sometimes I resort to magazines, newspapers and even paper serviettes, doilies and confectionery wrappers to create a special effect that cannot be acquired using any other way.

The permanence of most of these materials is, however, open to question – at the very least, none of them are acid-free and will therefore yellow with age even if painted, probably degrading the colour that has been laid on it. They are not watercolour papers and will be too absorbent for some areas and completely resistant to watercolour in others – nonetheless, an open mind is essential for this type of creative activity, and painting becomes much more exciting if a few risks are taken.

Techniques

As stated in my introduction on page 104, in a perfect world it would be better to begin a painting with the idea that collage will form a part of it, and not just act as a 'rescue' operation; but some of the most exciting paintings evolve from the failure of the more traditional techniques. I have used tissue paper, for instance, to cover up many a rejected watercolour and have continued painting on this to achieve success; and a number of my floral paintings have benefitted from using a collage of manufactured coloured paper, to intensify the colour of petals for example. With so many techniques available, I spend a great deal of time thinking my way through the technical processes needed for a painting before I begin, so that when I am actually painting I can concentrate on the creative processes.

Tissue paper

White acid-free paper helps to achieve reliable results – but it's best not to use coloured tissue papers, as these are not always colour-fast. Tissue paper gives a wonderful texture all over the piece, providing a 'crackle' effect and making paintings soft and atmospheric.

Handmade papers

Those papers with grasses, plant hairs, leaves and strands of silk can be used to create textures. They have little or no size and are therefore very absorbent, but with a little forward planning and some practice, very interesting and unpredictable results can be achieved. I usually give these papers a coating of PVA glue diluted to the consistency of milk before painting, which acts as a sealant, but successful painting also depends on getting the thickness of the paint right – washes that have little water but a lot of paint in them stay where they are put, but thin, watery washes will disappear to a gentle, shapeless stain. The gold and silver patterns in some of the more exotic papers will resist watercolour, being apparently oil-based, but I tend to use these where they need little or no paint, as backgrounds for instance.

Printed text

Photocopies, computer printouts and printed prose and poetry can be used for textures, detail and tricky areas of drawing. This is my personal favourite material, especially poetry. For many years I have been painting the images that are conjured up when reading poetry because they are so strong. To enhance and clarify the 'message' of the painting I have used either photocopies of the printed poem enlarged or maybe reduced in size, or computer printouts where different fonts are employed; I then cut these into shapes and use them as textures in the work – for instance, rocks in a poem about the sea, and ripples in dark water to depict water by moonlight.

Manufactured coloured papers

These can be used to create abstract shapes and texture. On top of a conventional watercolour background, patterns and shapes cut from coloured paper can be moved around before being stuck down, almost like a child's game. And although fairly thin, these papers can be painted on to help incorporate them into the picture. In addition to being available in many colours, some papers, such as those used for pastels, have a surface texture that is similar to watercolour paper.

Watercolour paper

Cut or torn, preferably lightweight 180gsm (90lb) paper can be used to enhance the three-dimensional appearance of objects in a painting, specially when they are in the foreground.

Discarded watercolour paintings

We all have some of these, or maybe pieces of painted watercolour paper. Never throw anything away, even the sample sheets that you test your colours on, because one day they might be just what you need for a collage, or for a specific texture.

PROJECT:
Woodland Scene

The beautiful heathland landscape where I live has been a major inspiration in my work. Every season, light, texture, weather and colour of the area is so familiar to me that painting it is almost instinctive.

Some artists find paintings like this complicated to achieve because of the textures involved, and end up overworking them, but watercolour and collage are particularly suitable because of the 'built-in' texture, which gives the work a greater depth and enhances the atmospheric effect.

When the painting is finished, my aim is that the viewer should be able to feel exactly what it is like to be walking through a pine wood in the autumn after rain – with the characteristic misty light, the smell of the muddy earth and the crackle of dead leaves and twigs.

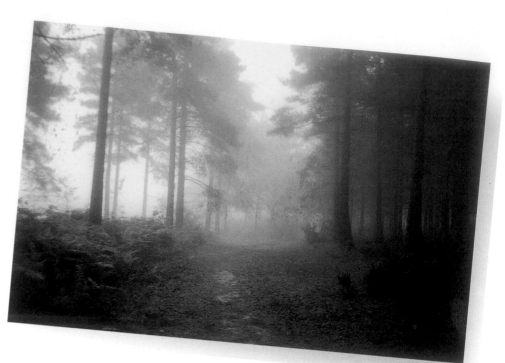

Above: *I took this photograph on one of my regular walks through the woods. Simple compositions of this kind often need an additional focal point of people or animals to complete them, so I keep my options open, hoping that details such as puddles and filtered light will be enough to sustain interest.*

Artist's Tips

■ I try to avoid getting any PVA on top of the tissue paper, as when it is dry it will slightly seal the surface, stopping the watercolour from being absorbed.

■ Despite what some watercolour purists may believe, I have never had any hesitation in adding opaque white and colours to my paintings to increase the drama and visual tension in a scene. There are no rules in painting – except what works.

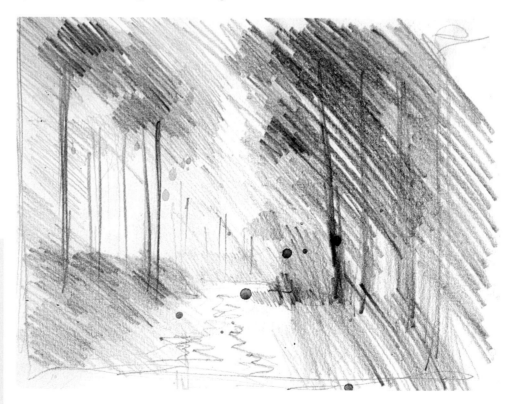

Above: *During the painting process I usually put the photograph away and complete the work from a rough sketch like this, which both simplifies the forms and tones, and suggests texture and atmosphere. This is a wise move, considering the pitfalls that come from working solely from photographs.*

Materials

- 35.5 x 51cm (14 x 20in) sheet of stretched 300gsm (140lb) Saunders Waterford hot-pressed watercolour paper
- Gummed tape
- Brushes:
 5cm (2in) flat
 No. 10 round
 No. 2 rigger
 No. 7 round
 2.5cm (1in) square
 1.2cm (½in) square

- Watercolours:

 bismuth yellow
 yellow ochre
 warm orange
 burnt sienna
 quinacridone magenta
 transparent turquoise
 French ultramarine
 phthalo green
 vivid green
- Mixing palette
- PVA glue
- Tissue paper
- Linoleum print roller
- 4B pencil
- Old watercolour painting on 180gsm (90lb) paper
- Acrylic ink:
 white

1 Without any preliminary drawing – always an inhibiting factor for me – I laid a basic wet-in-wet wash with a 5cm (2in) flat wash brush on a piece of stretched hot-pressed paper, starting with the lightest and warmest colours fairly centrally. This had the effect of setting the basic light source of the work.

2 Working out towards the edges, I laid the darker, cooler colours of the palette with the same brush, bearing in mind that because I was using watercolour, I needed to leave some areas (such as puddles) light. At the end of this process, I had produced a 'tonal tunnel' that was almost an abstract picture in itself.

3 When the underpainting was completely dry – this is essential if the process is to work – I diluted the PVA glue to the consistency of single (pouring) cream and spread it over the whole of the painting with an old brush.

4 Having first crumpled the tissue paper up to get rid of any folded creases, I smoothed it out again and laid it onto the wet glue, patting it down gently to avoid tearing it. The original underpainting showed through the tissue paper, creating a misty effect.

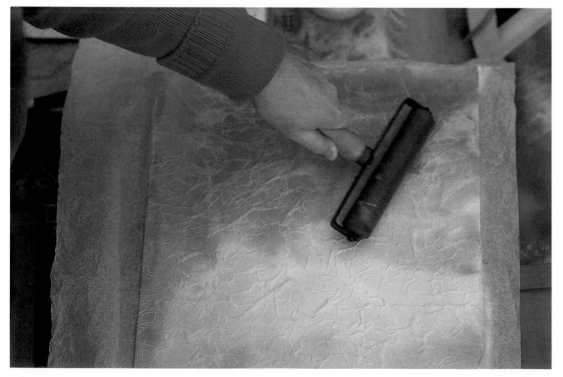

5 Using an old linoleum print roller, I gently rolled the air bubbles out of the tissue, because too many of these would weaken the surface of the painting.

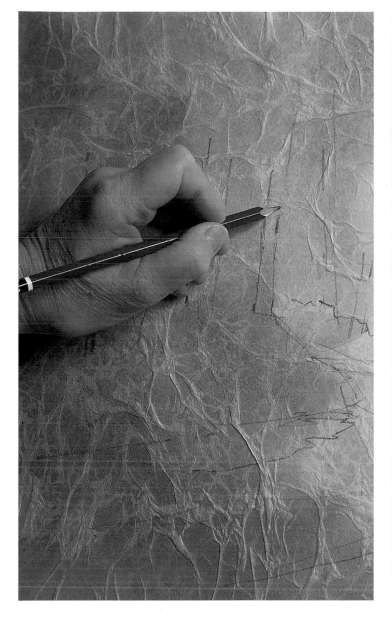

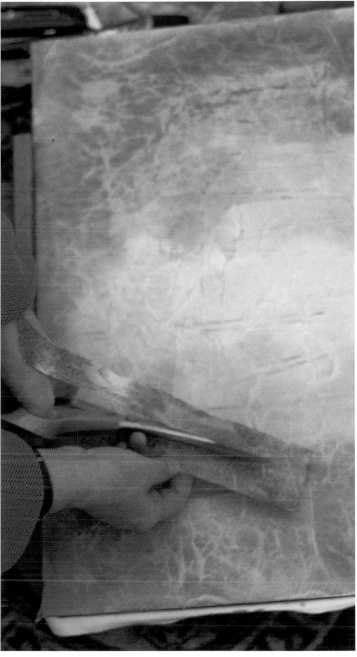

6 The painting had to be completely dry before the next stage: this was to gently draw in the main trees, path and puddles using a 4B pencil.

7 Now the fun started. I cut a tree trunk out of an old 'failed' watercolour painting that I had been saving. This painting, although discarded, had some beautiful textural effects on the edge; it was painted on 180gsm (90lb) watercolour paper, which made it easy to stick. I also cut some small leaf shapes out of the same piece for later use.

8 I checked the cut shapes against the painting to make sure the scale was right and that the piece fitted. Using old bits of watercolour paintings means that I can paint on them at the same time as the rest of the painting, incorporating them into the scene and thus giving the whole work more cohesion.

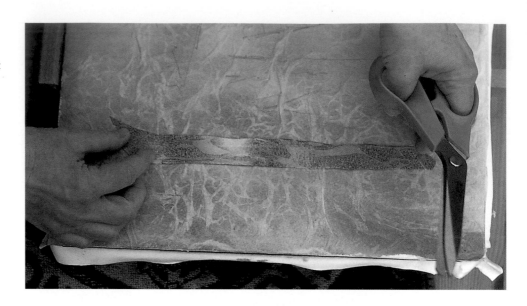

9 Using PVA straight out of the bottle – diluting it would mean the collage would be difficult to stick – I spread it onto the back of the tree shape. **Inset:** I then stuck the tree shape into place on the painting and allowed the glue to dry.

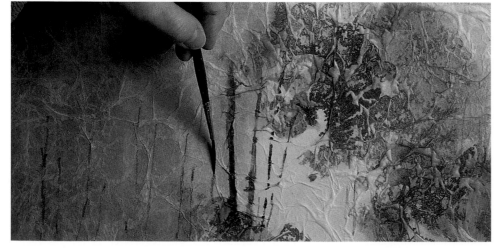

10 Next, I began to add more definition to the painting. Using a mix of French ultramarine and yellow ochre in a liquid wash, I painted the distant trees with a No. 10 round brush, adding details like the tree trunks in thicker paint with a No. 2 rigger.

11 I gradually moved forward in the painting with the round brush, using a thicker wash of French ultramarine and bismuth yellow for the trees in the foreground, and laying washes of warm orange and French ultramarine for the ferns and undergrowth. At this stage the thinner washes of paint ran randomly along the creases in the tissue paper, creating tree textures.

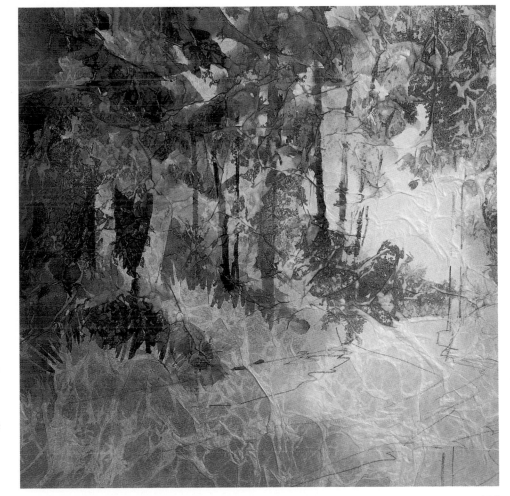

12 Bearing in mind that I was working in pure, transparent watercolour, I left the lighter areas of the painting, such as tree trunks, grasses and ferns, unpainted, 'cutting' them out with darker washes of transparent turquoise and warm orange, with French ultramarine and yellow ochre behind them. I used all the surfaces – point and side – of a No. 7 round brush.

PROGRESS REPORT

At this stage everything was in place as planned in the composition, and so I could now concentrate on achieving the textures I wanted. With the main shapes blocked in and the tissue paper creating a three-dimensional effect, I could start to work in pure watercolour, making the collage shapes more integral to the painting process, because they contained the colours of the underpainting.

Much of the time, this technique involves working in the negative spaces around the objects being defined, and therefore requires a degree of practice and awareness. This results in the painting being 'cleaner' as the lighter areas remain relatively untouched.

The shadows on the trees on the left are balanced by the collage tree on the right

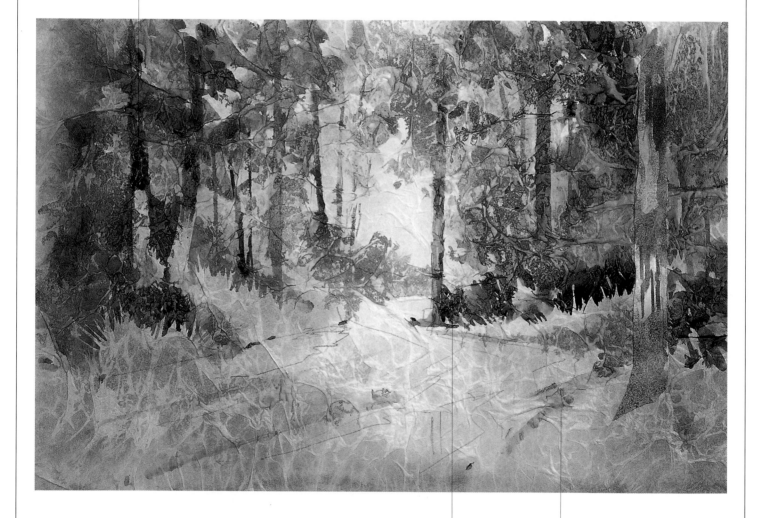

The darkest areas can be used as negative shapes to define the lighter parts

Contour lines on the ground are suggested by the collage

13 I am always conscious of the fact that paintings like this contain many verticals, so to increase rhythm and movement in the composition, I made sure that I added some strong diagonals when painting the tree trunks.

Inset: I then started to define the path with a wash of warm orange, using a 2.5cm (1in) square brush.

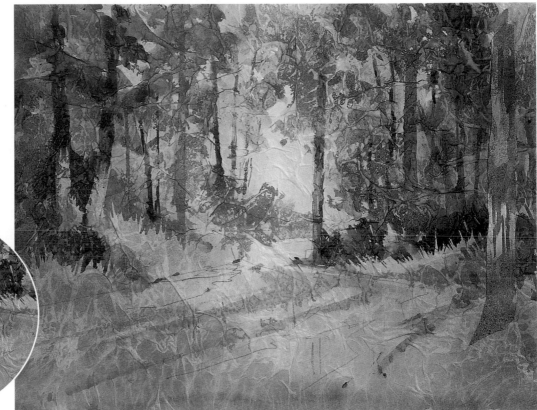

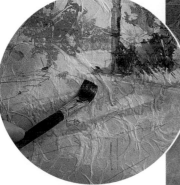

14 I continued to paint the path in warm orange, carefully leaving the puddle areas light, and noted with satisfaction how the warm orange darkened as it came to the foreground, because it was painted over the darker quinacridone magenta that I used in the underpainting. I then made crisp, darker marks at the edge of the path and puddles with thicker washes of French ultramarine and burnt sienna, using the rigger.

Inset: Nothing goes to waste – to give foreground texture, I stuck on the little leaves that I had cut out earlier.

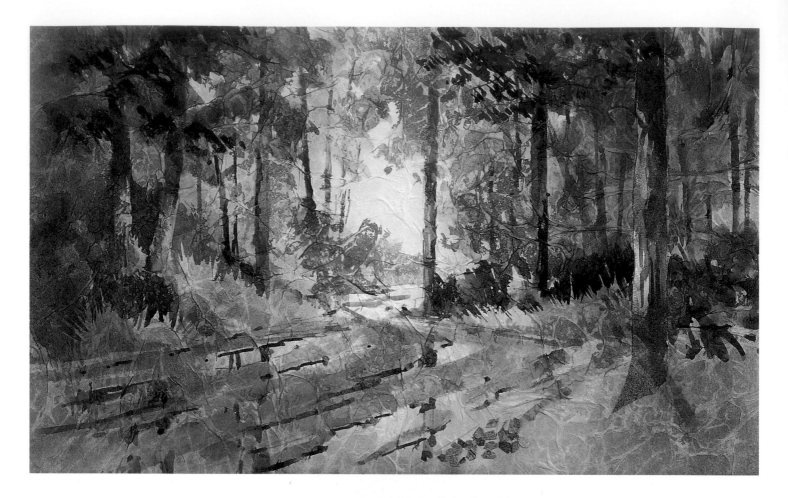

15 Now I knew that I was really working towards finishing the work. I painted the reflections of the tree trunks in the puddles with a 1.2cm (½in) square brush in vertical strokes, using for this French ultramarine and yellow ochre. Using a very thick wash of transparent turquoise, burnt sienna and some vivid green, I added the foliage to the foreground 'collage' tree, then adding shadows of quinacridone magenta and warm orange to the trunk underneath the foliage to make it more three-dimensional. Using the same mix, I painted the branches of the tree with the rigger while the foliage was still wet, thereby creating the 'lost and found' effect of branches threading through foliage.

16 Using a variety of mixes such as French ultramarine with transparent turquoise and warm orange, I painted fern and grass textures in the foreground with a lot of paint and a little water, using the No. 7 round brush, with the rigger for fine details. This made them crisp and clear and thus brought the foreground further forward.

Inset: At the same time, I incorporated the 'collage' leaves into the texture, painting over them carefully with the same colours.

17 I then painted additional shadows of French ultramarine onto the tree trunk with the No. 7 round brush, and painted fern shapes over it to incorporate it further into the painting and make it darker for the next stage of the painting. I also ran thinner washes of quinacridone magenta, French ultramarine and burnt sienna as shadows over the whole of the foreground path, to throw the lighter middle distance into greater relief.

18 At this stage I took some white acrylic ink and added some touches of glistening light to the tree trunks to make them look wet, using the No. 7 round brush. I also added some of this white around the reflections of the foreground puddles to increase the tonal contrast.

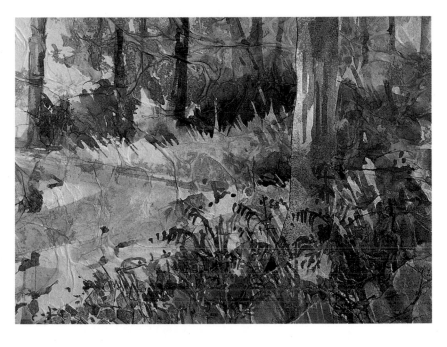

The Finished Painting

Turfhill Common, After Rain
33 x 48.5cm (13 x 19in)

Deciding when you have finished a painting is always difficult, but I feel that now I have run out of things to say in this painting I should stop talking! Using the simpler forms of collage, I aimed to create a painting that contained atmosphere and light, as well as an interesting surface texture that is not inherent to traditional watercolour. I have painted this scene many times, but using collage develops the subject further. Remember that in mixed media – as in life – the old saying applies: 'If you always do what you've always done, you'll always get what you've always got.'

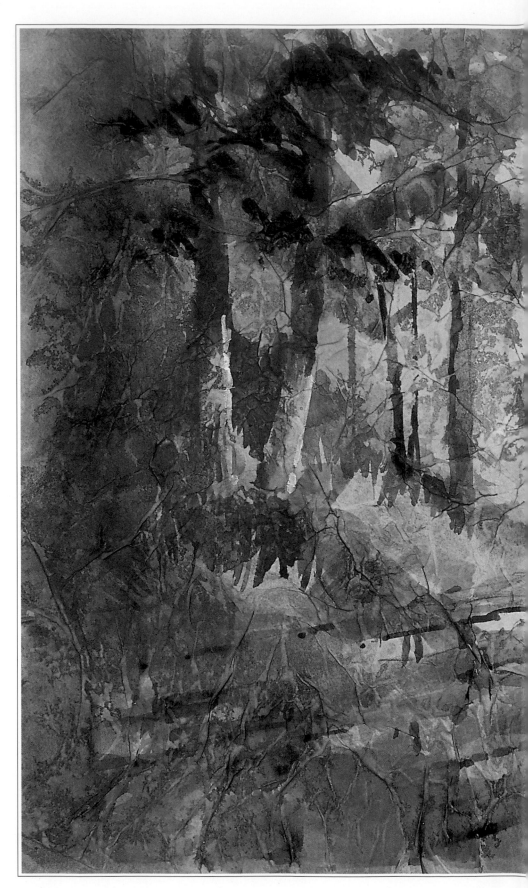

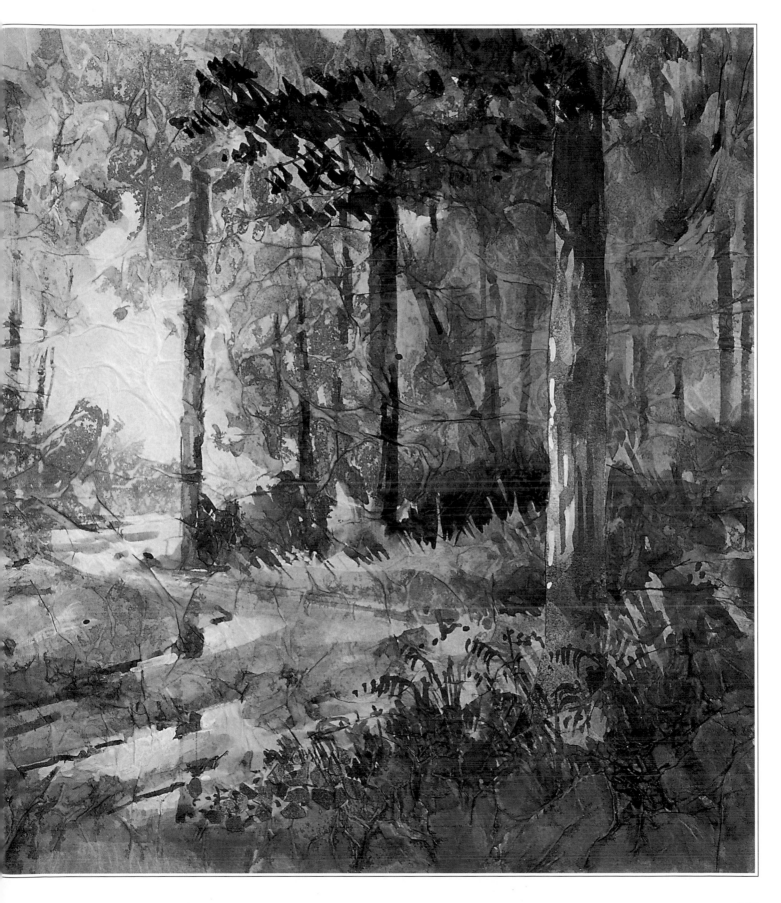

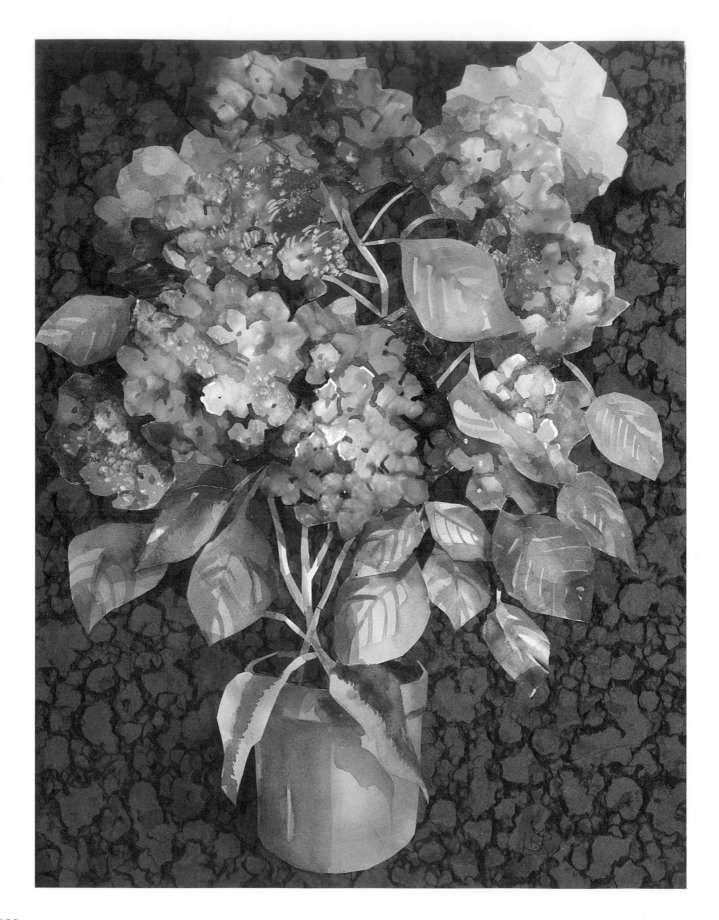

Opposite: **Hydrangeas**
56 x 46cm (22 x 18in)
Using a sheet of handmade paper mounted on card as a base, I 'constructed' this work out of a cast-off painting of Christmas trees covered in snow.

Above: **Poinsettia**
33 x 46cm (13 x 18in)
On a base of painted tissue paper I laid a collage of leaves and flowers, using old paintings and decorative handmade papers. I then added details in watercolour and 3D fabric paint.

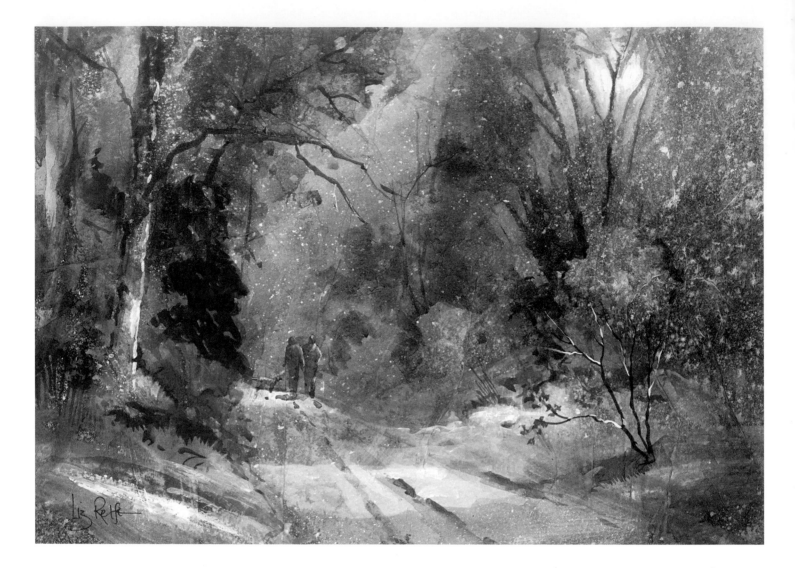

Winter Light
28 x 38cm (11 x 15in)
*An unexciting, failed watercolour lies
beneath the tissue paper on this piece. After
applying the tissue, I worked on the painting
in watercolour, using acrylic ink for spatter
and finishing .*

Golden Carp

38 x 46cm (15 x 18in)

*Three layers – handmade paper, tissue
paper and cut-out shapes – went into this
painting, each layer being painted with
watercolour. I applied finishing touches in
acrylic ink and imitation gold leaf.*

Watercolour *plus* . . .
THE CONTRIBUTORS

RAY BALKWILL

Ray worked as an art director in advertising until demand for his paintings led him to take up painting full-time in 1990. Since then, his work has been exhibited widely in the UK and has been hung in major open exhibitions, including the Royal Institute of Painters in Watercolour and the Royal West of England Academy. He is a member of the St Ives Society of Artists, contributes articles to *The Artist* magazine and has also contributed to *International Artist* and *Pastel Artist International*. He runs painting courses from his studio in Devon and throughout the UK and Europe.
raybalkwill@eclipse.co.uk

MIKE BERNARD

Mike trained at the West Surrey College of Art and Design, followed by postgraduate studies at the Royal Academy Schools. He has exhibited at the Royal Festival Hall and many galleries in London and throughout the UK. He has received many awards for his paintings, including the Stowells Trophy, the Elizabeth Greenshield Fellowship, the Silver Longboat Award and the Laing Award. He was elected a member of the Royal Institute of Painters in Watercolours in 1997, and two years later received the Kingsmead Gallery Award at the Royal Institute Exhibition at the Mall Galleries, London.
bernard62@freeserve.co.uk

MARTIN DECENT

Martin is a professional artist based at the new Yorkshire Artspace Studios in Sheffield, South Yorkshire, the first complex in the UK built for practicing artists. Painting in watercolour, gouache, acrylics and oils, he is a contributor to the Royal Society of Marine Artists, and has held a number of one-man exhibitions. He is published as a catalogued artist by Solomon and Whitehead, and is a contributor to *International Artist* magazine, which profiled his work in August 2000. His commissions include Cheltenham and Gloucester plc, Grant Thornton Accountants, the University of Leicester, Lloyds TSB Bank and the National Probation Service.
art@martindecent.co.uk

JOHN HOAR

The son of an architect who was also a distinguished watercolourist, John studied architecture at Cambridge University until he realised that he had no aptitude for its modern form and switched to painting. He became a student of Ruskin Spear RA, and spent a lot of time studying the work of the great watercolourists, concentrating on those who had perfected an economy of drawing and wash. After spending four years looking after a small art gallery he became a full-time artist in 1980, since when he has exhibited annually in one-man and mixed shows in the UK and Ireland at venues such as the Royal Hibernian Academy, The Royal Institute of Painters in Watercolour and the Singer Friedlander exhibition. He has written for *The Artist* magazine and holds regular winter painting classes.
john@hoar.freeserve.co.uk

WENDY JELBERT

Wendy's paintings have been exhibited in many galleries throughout the UK, and she has won Best Exhibit Awards at a number of shows, including the Society of Watercolour Artists in 1998. She is an accredited art demonstrator for Winsor & Newton and Daler Rowney, among others, and is a tutor at residential courses including West Dean, Sussex, Dartington Hall, Devon, and Dedham Hall, Essex. She is the author of many books on practical art, encompassing watercolour, pen and wash, watercolour pencils, acrylics and mixed media, and has made five teaching videos.
wendy@jelbert.com

LIZ SEWARD RELFE

Liz has been painting and drawing all her life, and her work is held in many collections, both in and outside the UK. She has exhibited widely, and many of her paintings have been reproduced as greetings cards and prints. For 25 years she has taught and demonstrated drawing, watercolour and mixed media to a wide variety of organisations. Light, colour, the heathland area where she lives and the flowers that she grows in her garden are the main inspiration in her work. She is a member of the Society of Women Artists and the Society of Floral Painters.
liz@relfe.force9.co.uk

Acknowledgments

The idea for this book has been germinating for some time, but without the help and co-operation of many people it would never have happened. Firstly, I should like to express my sincere thanks to Sarah Hoggett, the commissioning editor, whose enthusiasm and guidance have been paramount in producing this book. I am also grateful to staff at David & Charles for their assistance in its design and production, in particular Diana Dummett and Freya Dangerfield, and the freelancers who worked on the book, Ian Kearey and Sue Rose. Then the contributing artists themselves: Mike Bernard, Martin Decent, John Hoar, Wendy Jelbery and Liz Seward Relfe, in the order in which they appear. Their co-operation throughout has been as excellent as their own paintings. Many thanks also to photographer and friend Nigel Cheffers-Heard for his expertise and superb photography to be found within these pages. Finally to the patrons, for allowing the reproduction of my paintings from their private collections.

RAY BALKWILL

Index